Northfield
Park

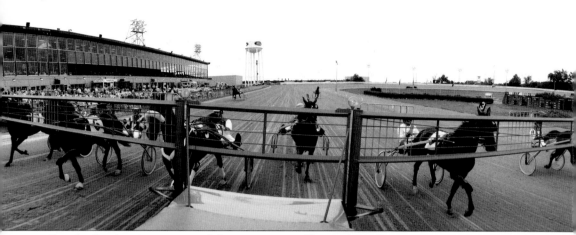

Standardbred racing uses a mobile starting gate. Here a field of trotters is just about to start a race. Northfield Park Wall of Famer Don McKirgan is driving the No. 3 horse. McKirgan, who has competed at Northfield every year since 1957, is currently recovering from Guillan-Barre syndrome, a nervous disorder which left him paralyzed. Early in the summer of 2004 he returned to training and jogging horses, though he has yet to drive.

NORTHFIELD PARK

Keith L. Gisser

ARCADIA

Published by Arcadia Publishing
Charleston SC, Chicago, IL, Portsmouth NH, San Francisco, CA

Printed in Great Britain

Library of Congress Catalog Card Number: Applied for.

For all general information contact Arcadia Publishing at:
Telephone 843-853-2070
Fax 843-853-0044
E-mail sales@arcadiapublishing.com
For customer service and orders:
Toll-Free 1-888-313-2665

Visit us on the internet at http://www.arcadiapublishing.com

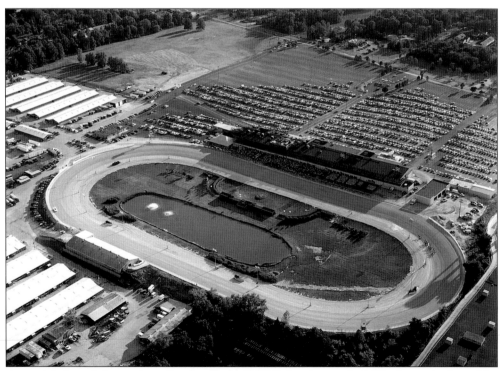

An aerial view of the track on Battle of Lake Erie Night, August 1, 2001, shows the barn (the track has barn space for over 800 horses), a full parking lot, and the grandstand/clubhouse complex. The horses in this photo are in Cuyahoga County and will enter Summit County in about 20 feet. The track straddles the two county lines.

CONTENTS

The "America Races Here" slogan on the neon sign at the entrance to Northfield Park replaced "Every 19 Minutes the Place Goes Crazy" in the early 1990s, as simulcasting from more and more locations was offered at the track.

INTRODUCTION

Since its founding in 1957, Northfield Park has gone from being part of a four track circuit, racing just a few months a year, to a year-round entertainment facility featuring over 200 nights a year of live racing and offering simulcasting—wagering on other racetracks—364 days a year. It is the only racetrack in Ohio that races year round, making it a popular option not just in Ohio, but in the casinos and sports books of Las Vegas, the off-track parlors of New York and Illinois, and even the teletheaters of Ontario. There is no way Walter Michael could have imagined the spread of harness racing from Northeast Ohio across the continent when he envisioned a new track to join the circuit that included Grandview Raceway, North Randall, and Painesville. Of those three, only Painesville still exists, featuring matinee racing and the Lake County Fair Stakes.

This book takes a look at Northfield Park from its early days as a harness track and even before, to the days when gangster Al Capone envisioned a dog track for the space that straddles the Cuyahoga and Summit County lines. When that enterprise failed, the space became a sprint car track, eventually being purchased by Michael, who operated the prestigious Pickwick Farms Standardbred breeding operation. Many of the same people who worked at and maintained the auto track worked at the racetrack for that inaugural meet in 1957; in fact, the tar was still drying in the parking lot on that hot August night when pari-mutuel harness racing made its debut at the facility. Several women needed help extricating their heels from the gooey mess, but that opening night was a success and the track never looked back.

The track thrived for many years, but fell on hard times in the early 1980s. Developer Carl Milstein had purchased the track from Michael in 1972, but was leasing it to private operators. Things got so bad at one point that Milstein would send his right-hand man, Myron Charna, to the track on a daily basis to pick up the lease payments. In 1985, Milstein regained control of the racetrack and the facility experienced a renaissance, with growing crowds and rising purses. It was during this time that the prestigious Battle of Lake Erie Free-For-All Pace was developed, as were many other top stakes races. It was also just after he regained control that one of the most memorable advertising phrases of in Cleveland history was coined: "Every 19 minutes, the place goes crazy." Sung by a young unknown (at the time) named Jim Brickman, the slogan, disused for nearly 20 years, is still quoted by politicians, patrons, and radio and television personalities on a regular basis.

In 1995, with the advent of full-card simulcasting, the track embarked on a multi-million dollar renovation, featuring state-of-the-art simulcasting areas, where customers could work and wager in comfort, with private televisions. The clubhouse was completely refurbished and the track became the first (and still only) racetrack in the world with its own microbrewery on premises.

Today, the racing landscape has changed considerably, with convenience wagering and remote simulcasting often taking precedence over live racing at many facilities. But despite the passing of Carl Milstein in 1999, Milstein's son Brock continues to emphasize the importance of the live racing experience at the Northfield Park, the home of the Flying Turns.

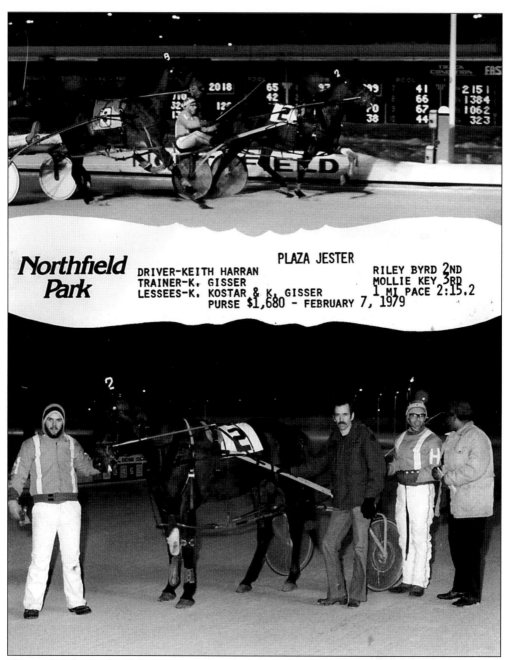

Northfield Park

PLAZA JESTER

DRIVER-KEITH HARRAN
TRAINER-K. GISSER
LESSEES-K. KOSTAR & K. GISSER
PURSE $1,680 - FEBRUARY 7, 1979

RILEY BYRD 2ND
MOLLIE KEY 3RD
1 MI PACE 2:15.2

The author had a brief, but successful career as a trainer of pacers and trotters. Here he is pictured with his best horse, Plaza Jester, who won 10 races in 1979. The author is holding the horse's head and is accompanied by K. John Kostar, Plaza Jester's owner; driver Keith Harran, who retired from racing to become a professional poker player; and Barry Thompson, a friend and eventual partner on several horses including the pacer, Liberty Kid.

ONE
The Early Years

In the mid-1950s, Ohio was a hotbed of standardbred racing. Pacers and trotters plied their trade at literally dozens of tracks, many at county fairgrounds. In Northeast Ohio, the circuit consisted of Grandview, operated by Northfield's founder Walter J. Michael, and Painesville, located at the Lake County Fairgrounds, as well as North Randall. These were older tracks, however, without the amenities of clubhouses and modern totalisator (tote) equipment. Walter Michael, one of the most successful breeders in the sport through his Pickwick Farms, had visions of a modern facility that would be a destination not just for the avid racing fan, but for the casual attendee as well. Michael purchased the Sportsman Park sprint car track and immediately went about renovating the facility as a harness track. The track had originally been built in 1934 and was intended to be a greyhound track. The sprint cars raced on the site for 20 years, but interest began to wane and, in 1956, the track was demolished to make way for Northfield Park. Michael also campaigned for a huge stable of race horses, including Miss Gene Abbe, who later appeared as the equine star of the motion picture, "Home in Indiana."

That first season of racing, in 1957, featured some of the region's top horsemen included future Ohio Hall of Famers Bill Popfinger, "Bud" Parshall (son of the legendary Hall of Famer Doc Parshall), Dick Richardson, and Dick Brandt. Also competing were future household names John Caton, Fritz Newhart, George Ursitti (who would later go on to stardom as a professional wrestler), and youngsters Joe Adamsky, Gerry Bookmyer, and Don McKirgan.

A young Joe Adamsky pilots Fan Meto Clay to a one-and-a-half length victory in the second race on July 8, 1960. This *Cleveland Plain Dealer* photo is one of hundreds that were "orphaned" and given to Northfield Park by the paper when they cleared out their "morgue," in anticipation of a move to new quarters.

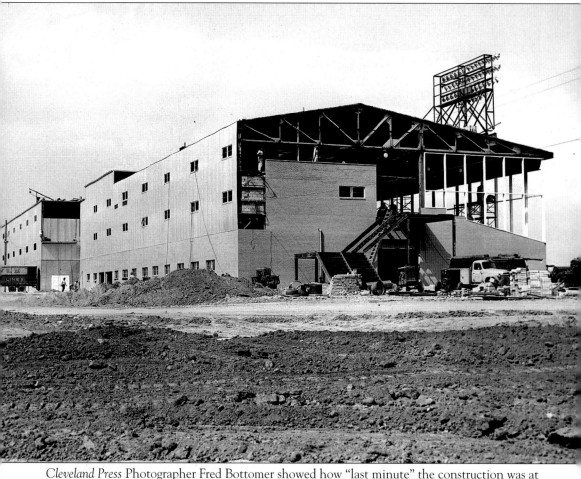

Cleveland Press Photographer Fred Bottomer showed how "last minute" the construction was at Northfield Park in this August 30, 1957 photo. The picture was discovered at American Book and News in 1980.

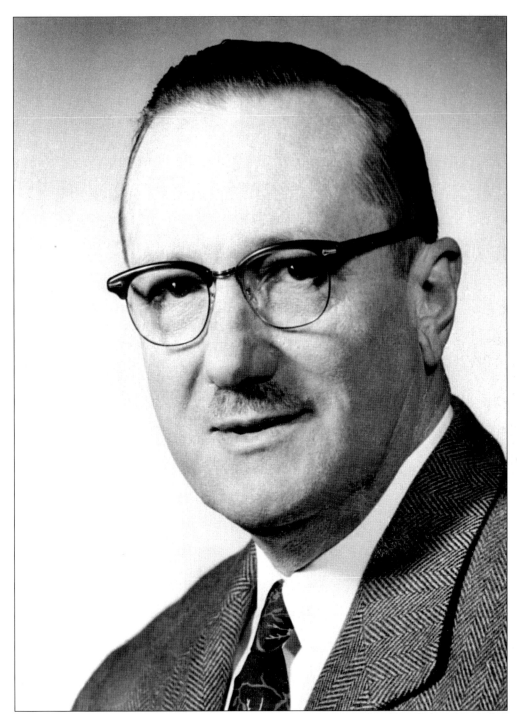

In this studio shot, courtesy of the U.S. Trotting Association, Northfield Park founder Walter J. Michael is shown without his ever-present pipe. In addition to constructing and operating Northfield Park, Michael operated Grandview Raceway and Pickwick Farms, one of Ohio's premier breeding operations. Pickwick Farms still exists today, under the ownership of Ohio Supreme Court Justice Paul Pfeifer.

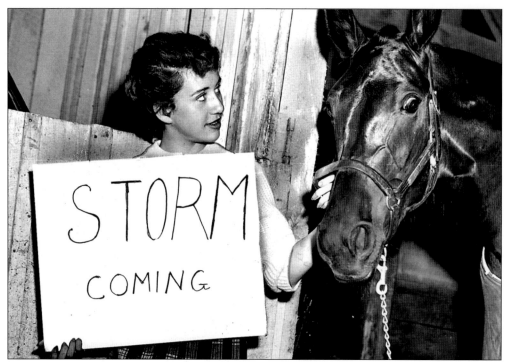

The horse in this 1958 photo is Dust Storm. He is accompanied by Lakewood's Denise Jarvis, who is holding the high-tech prop sign. These shots required lots of extra lighting, and if you look closely, you will note the horse has an unnatural shine to him.

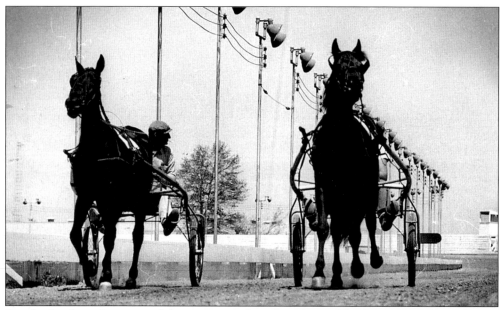

Standardbreds get far more work between races than their thoroughbred cousins. In the early days, it wasn't unusual for trotters and pacers to jog four slow miles daily and to train three fast miles twice a week. This photo promoted the opening of the 1960 season at Northfield Park. Check out the lighting that pacers Wilford D.N. and Squawkin' Squaw had to race under back then.

Jean Laird and Dianne Dettman pose for the camera. The bathing beauty shot was a popular one for the papers, although very few bathing suits were in evidence on the backstretch on a typical workday. By the way, Jean Laird is the trotter, Diane is the one in the one-piece.

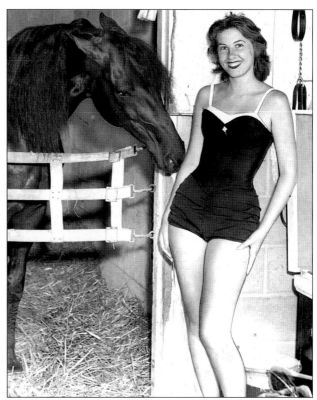

Lassie would have been jealous of Daisey Mae, who could apparently drive the three-year-old trotter, First Try, owned by Tony Raber of Strasbourg, Ohio, despite her lack of opposable thumbs. The Raber family is still active in the sport to this day. First Try is hitched in a jog cart, a longer, heavier training sulky than the one he would race in.

Jack Leonard was one of the top conditioners at Northfield Park in the early days. Here, his daughter, Sally, does her best Shirley Jones impression as she poses with Indian Creek, who was scheduled to start in the Inaugural Handicap at the track. Leonard owned the horse, too. Without the background information, this photo could easily have been a still from the Pat Boone/Shirley Jones harness racing film, "April Love."

Some things in harness racing never change and one of them is the fact that all the equipment—harnesses, hobbles, even sulky tires—must be cleaned and maintained. Here, Gus Borne works on the sulky wheel of Denzil Berry. Although he never won a Northfield driving title, Berry was one of the tops in the sport in the late 1950s and early 1960s.

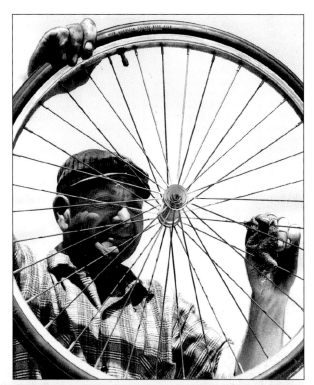

Popular east side Cleveland Chevy Dealer Joe O'Brien, not to be confused with Hall of Fame Driver Joe O'Brien, often gave away cars to Northfield fans as a promotion. Here he gives away a trophy to trotter Ukiah and his owner William Lachenmier. That's driver Ken Cartnal in the bike. The heavy boots on Ukiah's front feet are called bell boots, while the boots worn behind are called shin boots.

Fritz Wenzel takes a shot of Harvest Glory, who had won six races by September of 1961. Wenzel's family, including his dad Dick, were partners in many successful horses with the Michael Family, descendants of the track's founder, as well as with the Newhart family, who dominate the Southeast Ohio racing scene to this day. Fritz also had a career as a driver and trainer, winning 246 races. He last drove at Northfield in 2001.

Although race bikes have changed greatly over the years (see chapter 2) jog carts have not. In the immaculate Bruce Nickells barn of 1962, the jog carts are lined up and cleaned by Jerry Johnson. Nickells was named to Northfield's Wall of Fame in 2001, and his daughter, Brooke, and son, Sep, are still active in the sport.

Bret Hanover may have been the greatest pacer of all-time. He was the Little Brown Jug champ in 1965, when he went undefeated. He is shown in 1964 at Du Quoin, Illinois, but his owner, Richard Downing, lived in Shaker Heights, Ohio, a Cleveland suburb. The colt raced at Northfield several times. At one time he held Northfield's track record.

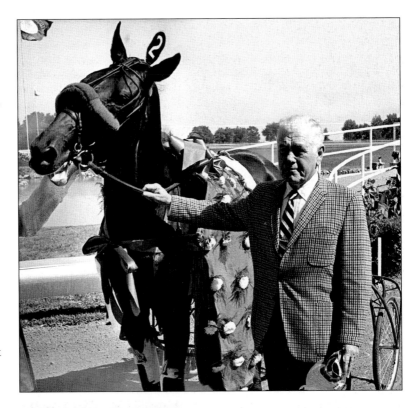

Northfield's back track provides a serene, wooded setting for horses that may get too excited to exercise on the main track. But who wouldn't be excited to be held by attractive Shelly Klineman? This is Cleopatra Hanover, who in June of 1961 was the fastest pacing mare at the track. The Scott Stable of Warsaw, Virginia, owned the pacer.

Owner Catherine Matich let's her three-year-old trotter, Devil Dancer, know that post time is drawing near in this staged photo prior to the 1961 Grandview-Ohio Futurity. Matich still owns horses that race at Northfield Park. John Caton, Northfield's first driving champ, trained and drove Devil Dancer.

Racebikes, or sulkies, were virtually unchanged from the 1920s until the early 1960s. Ilene Bayless and Suburbanite are shown in this 1963 photo, along with a typical racebike of the day. Suburbanite must not have had much success at the races, because the name was used again in the 1990s by a top invitational pacer who currently stands at stud in Indiana. Horse names are limited to 18 letters and spaces and cannot be reused within a timeframe set by the U.S. Trotting Association.

Hall of Famer George Sholty shares a cup of coffee with Coffee Break prior to the $11,600 Harness Tracks of America leg at Northfield Park in September of 1963. The traveling series pitted top horses with a final at the (now defunct) Roosevelt Raceway. At Northfield, Coffee Break faced off against Adora's Dream (*below*) in a memorable duel. The pair battled throughout the year in the series.

Adora's Dream, along with Coffee Break (*above*), was thought to have a chance at the first 2:00 miracle mile in Northfield history, although it turned out fans would have to wait for Lavender Laddie to turn the trick nearly seven years later, in 1970. Adora's Dream won a quarter of a million dollars in his career—a nice chunk of change for the era.

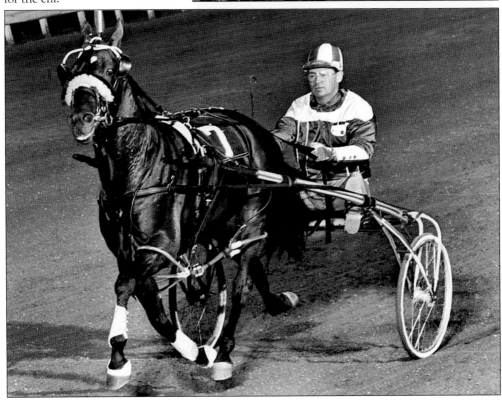

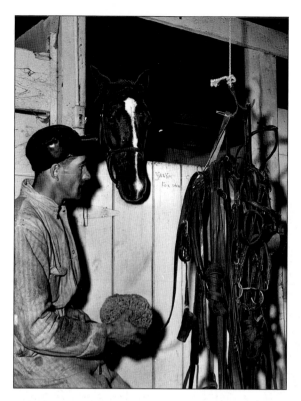

The best barns always paid attention to detail. A clean harness is a must for a horse to succeed. Two-year-old Anka K wants to make sure that Don Keeton does the job right. Note the long straps or traces on the harness. These were wrapped around the sulky shaft several times to help secure the harness to the jog cart or race bike. The development of the Quick Hitch sulky attachment and brackets are the only major change to harnesses in the last 50 years, although the change allowed for the elimination of the breast collar, which also secured the bike.

In 1966, World Champion Royal Gene Pick came to Northfield to compete in the $12,347 Grandview-Ohio Futurity. The son of Gene Abbe was foaled in Chippewa Lake, Ohio, between Medina and Wooster and equaled Frisco Creed's eight-year-old world record with a 1:59 win at Vernon Downs in New York in 1963. He is shown with his trainer, Al Todd

20

Someone forgot to tell two-year-old Steve Melchoir to make sure to wear a safety helmet whenever jogging a horse. He is shown sitting behind Commando Way, a trotter, just outside of Barn C at Northfield. The breast collar, mentioned on page 20, is easily seen here, as are the traces attaching the harness to the cart. Note the toe weights on Commando Way, which help to balance trotters and extend their stride.

Media coverage of harness racing in the late 1950s and early 1960s was much different than it is today, as shown in this humorous shot of trotter Reno Bell Tass attempting to handicap his chances with 14-month-old Denise Richmond, whose dad worked for the trotter's owners, Tass Farms.

Another example of the difference in media coverage of the sport back in the 1960s, Judy Szabo and Dudley's Dandy both seem relieved that Judy's feet aren't in the stirrups in this photo shoot from 1964. No sports editor in the world would run a "sexist" photo like this today.

Patty O'Donnell, age 11, is shown with Golden Knight, a horse trained by her father Robert O'Donnell in this 1965 photo. Bob O'Donnell, best known for his work with filly pacers including Impatiens, Strike Out Babe, and Braless, was named a Northfield Park Distinguished Owner in 1998. His picture hangs in the clubhouse, just below the Wall of Fame. Patty's brother Kelly is currently a top trainer, racing horses at Northfield Park and throughout the Midwest showing that harness racing truly is a family affair.

One constant of harness racing, not just at Northfield, is the time families spend together at the racetrack. Here, Pete Smith's daughter, Sue, and her brother pose in a special jog cart constructed for their pet pony, which lived in Barn G. Note the paddock in the background of this shot. The exterior is virtually unchanged since this 1967 picture, which was provided by Sue (Smith) McLaughlin.

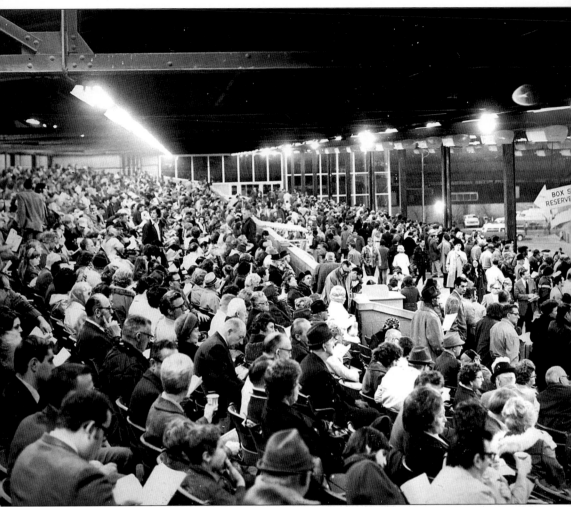

Pictured is a packed second-floor grandstand on opening night of the 1972 racing season on April 20. This was before the days of winter racing or year-round racing, and an opening night was always as much a social occasion as a chance to wager the bankroll that had been accumulated through the off-season.

Two
The Times
They Are A' Changing

As Northfield Park headed into the 1970s, it faced challenges from other forms of entertainment, not the least of which was television. Television was not widespread in the 1950s, when the track opened, but was now ubiquitous. On-track giveaways and promotions, which were done more as fan appreciation events in the early years, were needed to assure large crowds on a regular basis.

The major reasons that Northfield thrived in the 1970s were its horses and horsemen, including Lew Williams, the greatest African-American driver in the sport's history. As the track moved into the second half of the decade, the horsemen embraced winter racing and an innovative schedule of odd-distance races. Handle and purses soared and the human and equine stars of the sport made a point of "barnstorming" through Northfield.

In the early 1980s, however, the lessees of Northfield Park saw a drop in business and Carl Milstein was forced to seize control of the track. He immediately set to work restoring the trust of fans, horsemen, and suppliers. He embarked on a renovation of the track and brought in a new management team. The track's premier race, the Battle of Lake Erie, was established and the track began receiving rave reviews, and business rallied. The Golden Age of the "New" Northfield Park ran into the early 1990s, only to be ended by Ohio's archaic simulcasting laws, which limited the number of races from other tracks that could be brought in for wagering.

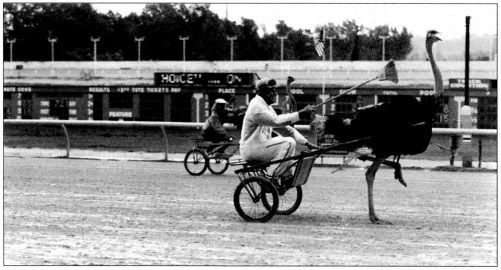

In 1986, ostrich racing came to Northfield in a non-wagering event. In the foreground is Mel Turcotte, using a broom to steer his mount across the finish line first. This was one of many innovative promotions the track used to regain its fan base in the mid- and late 1980s, after Carl Milstein regained control of the track.

Top, left: Perhaps nothing illustrates the changing times more than the changing facial hair of popular track announcer, Greg Young. One of the most humorous announcers in the business, Young is shown in three undated photos. This is Young as he appeared in the early 1980s after working alongside the legendary Andy Cunningham in the late 1970s.

Top, right: Here is Young in 1986, after he became Northfield's only announcer as the three meets held at the track were consolidated under one management. By now he had cemented his reputation as one of the most unique announcers in the business.

Left: Here is Greg's Northfield Park Wall of Fame induction photo from 1995, when he joined his mentor Andy Cunningham, who joined the Wall in 1990.

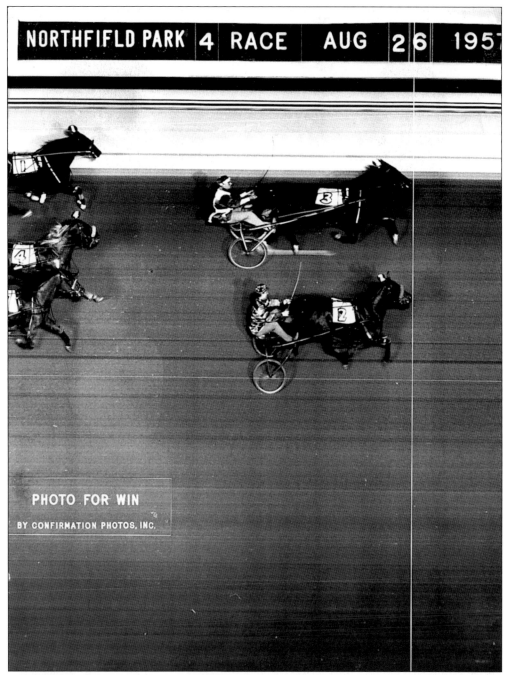

NORTHFIFLD PARK | 4 RACE | AUG | 26 | 195

PHOTO FOR WIN

BY CONFIRMATION PHOTOS, INC.

This is the photo finish of the first dead heat for win in Northfield Park history. As you can see, it occurred in the fourth race on August 26, 1957. On the inside (top) is Society Bell, driven by Denzil Berry, while on the outside is the much smaller pacer Dutchess Boy, driven by Aubrey Worline. As time progressed, photo finish equipment became more and more sophisticated. Today, computers are used. They not only determine the photo finish, but also calculate the number of lengths back each horse in the race finished.

Harness racing is a dangerous sport. Horses travel in excess of 30 miles per hour without power steering or brakes, while drivers wear little protection other than their helmets. When the track opened, the decorative silk caps worn had a hard lining, but offered little true head protection.

By the late 1950s a hard helmet had replaced the more decorative silk cap. Note the very wide brim and lack of ear protection. This is John Hague feeding Buckeye Queen, who must be dangerous, indeed, if a helmet is needed to simply giver her grain.

By the early 1990s, the helmets had changed little, although painting procedures began to turn them into works of art. Here is Mel Turcotte warming up Northfield Park-regular Pickwick Baron at the Little Brown Jug in Delaware, Ohio. Pickwick Baron was named to Northfield's Wall of Fame later that year. Note that Turcotte's helmet has earpieces and a chinstrap, making it much easier to keep on his head.

The modern helmet is pre-tested and safety approved. It is much larger than the helmets that preceded it, with a shock-absorbing interior. This is Todd "Corky" Jones. Note the intricate artwork on this helmet.

Winter racing came to Northeast Ohio in the late 1970s and proved very popular. In the days before Gore-Tex and UnderArmour, drivers had to make do as best they could to stay warm. Here driver/trainer Bob Lippiatt displays his fur-lined colors. Unlike thoroughbred racing, harness drivers each have their own registered colors, making them easily identifiable wherever they race.

Racing in cold weather brought a whole new dynamic to racetrack maintenance as this 1976 photo shows. The front-end loader was converted to a snowblower as horses continued to train around it. This was also an issue for horses, who are creatures of habit, as they had to get accustomed to the odd goings-on around them.

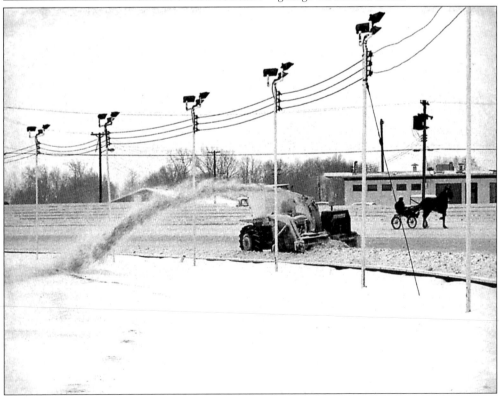

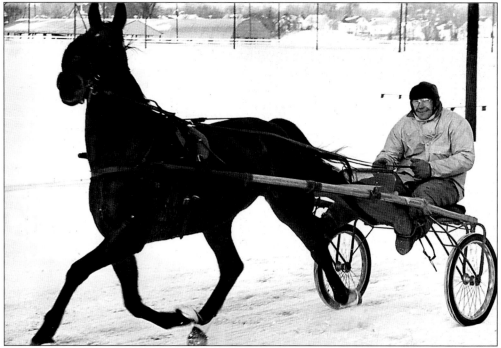

Although winter racing didn't begin at Northfield until 1975, winter training occurred at the area fairgrounds around Northeast Ohio. Young horses need to learn their trade and get hundreds of miles "under" them before they are ready to race. Here is Bill Pocza and trotter Guy Garrett in a 1965 *Plain Dealer* photo.

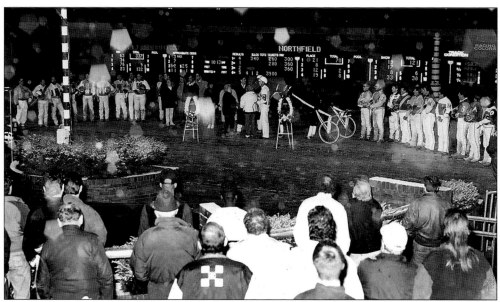

When John Caton, Northfield's first driving champ passed away in 1993, the traditional driverless horse was led to the winners circle, along with a huge contingent of drivers, despite the snowy weather. Similarly, when President Ronald Reagan passed away, his funeral procession was accompanied by a riderless standardbred referred to by the U.S. Army as Sergeant. York.

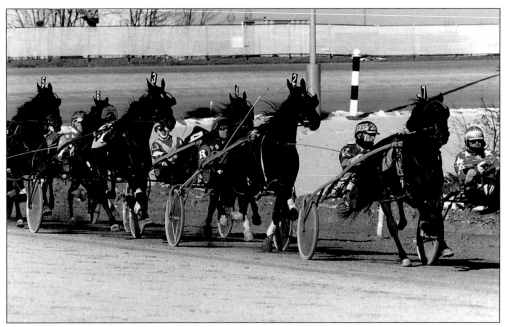

Around the turn and heading for home (and the heated paddock). That's Steve Carter in the lead, with Keith Kash second. Dan Ross is driving the No. 2 horse and further back is Bill Popio (behind No. 4) and Jim Pantaleano driving No. 3. Check out the wide variety of methods used by the drivers to keep their faces and hands warm.

This winter shot shows the clubhouse (now called the barbecue) turn and the paddock of Northfield Park on a typical winter day. Compare the paddock's appearance to the photo on page 23. At least the lights have been modernized.

Pictured is the glass enclosed grandstand and clubhouse. Although the clubhouse at Northfield Park is permanently enclosed, the grandstand windows slide open, to allow fresh air in during the warmer months. Although a recent photo, the weatherization of the grandstand occurred in the mid-1970s.

Here is a comparison shot of the clubhouse and grandstand, as seen through the eyes of Don Swick's horse, Rocky Supreme. This 1971 photo predates the weatherization project by a few years. The structure on top of the building houses the announcer's booth, press box, and judge's stand. Today the area also serves as the track's TV control room and studio.

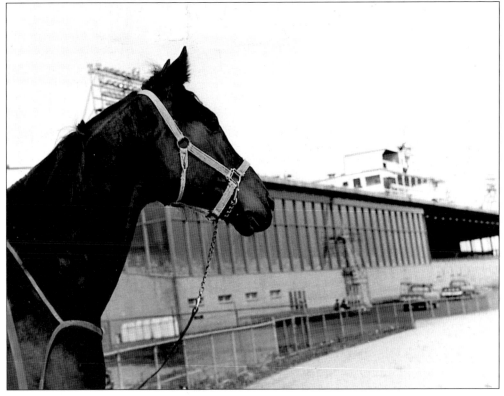

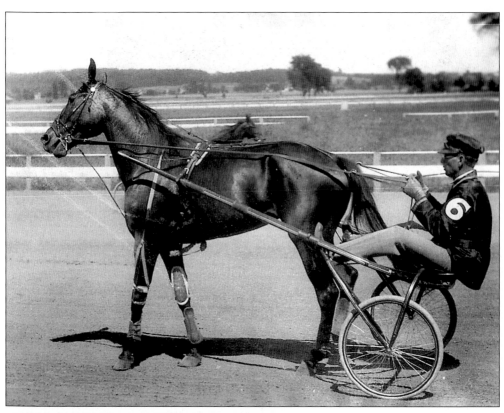

Sulkies changed little once the major innovation of bicycle tires were added. This is a 1927 shot of Miss Pansy, a stakes performer of her day. Compare this race bike to the one illustrated on page 18.

By 1973, the sulky was a bit more aerodynamic, with enclosed wheel discs, but was still very similar to the bikes of 50 years previous. This is driver Don Irvine, Jr. with his son, Brad. Don was elected to Northfield's Wall of Fame in 1991. At one point he won eight of nine driving titles, with the streak broken only by his brother Bill. Don has won over 5,000 races in his career, while son Brad, now in his late thirties, splits his time between Florida's Pompano Park and Plainridge Racecourse, located near Boston, Massachusetts.

The single shaft sulky was a short-lived innovation of the early 1970s. Designed by Joe King and used here by Bud Foster at Windsor Raceway, it was highly aerodynamic, but was deemed unsafe due to the single attachment to the horse.

The modified sulky combined many of the aerodynamic refinements of the single shaft bike, but kept the double shafts. This bike has the quick hitch attachment, allowing the horses harness to actually snap into the shafts. This innovation was developed in the early 1990s. The latest incarnation of the race bike includes additional lift, space age metals, an offset seat to overcome centrifugal force in the turns, and wheels adopted from Lance Armstrong's bicycle racing research.

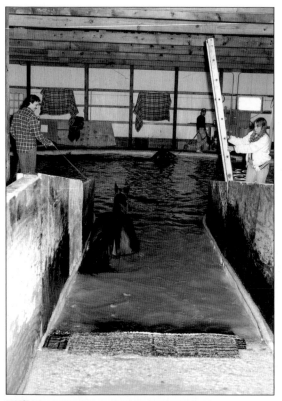

Northfield was one of the first tracks to offer a therapeutic swimming pool on the grounds. The pool was built in the early 1970s and was operated by Howard Adler, who specialized in rehabbing horses with lameness. Many responded to aerobic exercise in the pool. Today, Amy and Calvin "Buck" Hollar operate the pool, and horses are sent to them from across the country to rehab in the pool. Horses enter down a rubber covered ramp.

And they really do swim. The pool is deep enough that their hooves cannot touch bottom. A 10 to 12-minute swim is usually the equivalent of a three mile jog, but horses swim at their own pace.

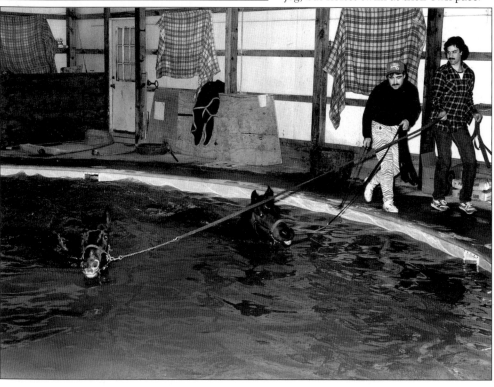

One of Northfield's most popular promotions of the 1970s wasn't an original. This is Wedgewood Lady, with young Teddy Powell. She was awarded to a Northfield Park fan in celebration of Pickwick Farms 20th anniversary. Pickwick Farms was the breeding farm operated by Northfield founder Walter Michael.

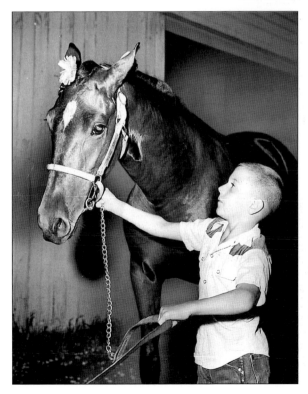

If it feels like déjà vu all over again, that's because the 1960 photo of Earl Bowman's son Gary with Northfield Wick, a yearling filly, heralded the fact that she would be given away to a lucky fan as part of Appreciation Night.

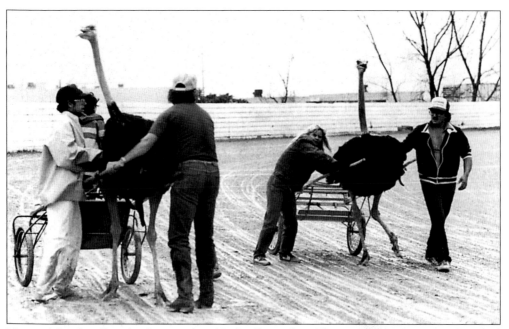

No quick hitch sulkies for the ostriches. No bridles, either. These scenes are so unusual we had to throw in a few more pictures of them from 1986.

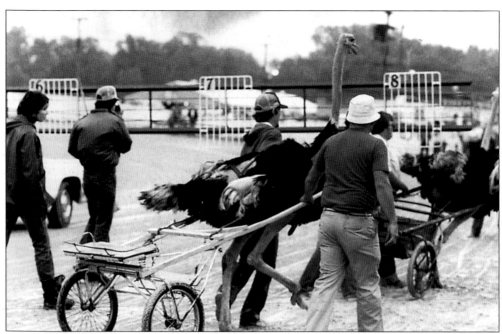

"The ostriches move in behind the gate and Here They Come." Typical (?) ostrich races begin from a standing start, so these ostriches had to school behind the gate to get used to it, which is easier said than done.

The track's 60-Second Winning Sprees of the 1970s and 1980s were revived with great interest in 2003 at Northfield. Contestants chosen at random had 60 seconds to call out as many $2 wagers as they could, keeping their winnings. A number of different strategies cropped up over time, but the best strategy seemed to be not to run out of breath. In the 2003 version of the spree, celebrities from local radio and TV stations were also brought in to compete for charity.

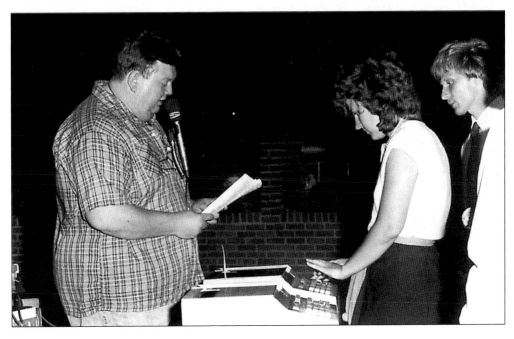

In the spirit of Glasnost, a team of Russian drivers competed at Northfield in a special promotion. The 1989 debut of Soviets saw Vitaly Tanishin steer Lakewater Glory to a new track trotting record of 1:57.4, which stood until the late 1990s. Of course the Russians were welcomed with a great deal of pomp and circumstance. Check out the big crowd staring through the doors on a rainy night.

The Russians got a rematch in 1990. Here is the entire contingent, with their welcoming gifts for the Americans. Northfield's first driving champ, John Caton, was of Russian descent and traveled to Russia regularly to help with the development of the modern Orloff Trotter.

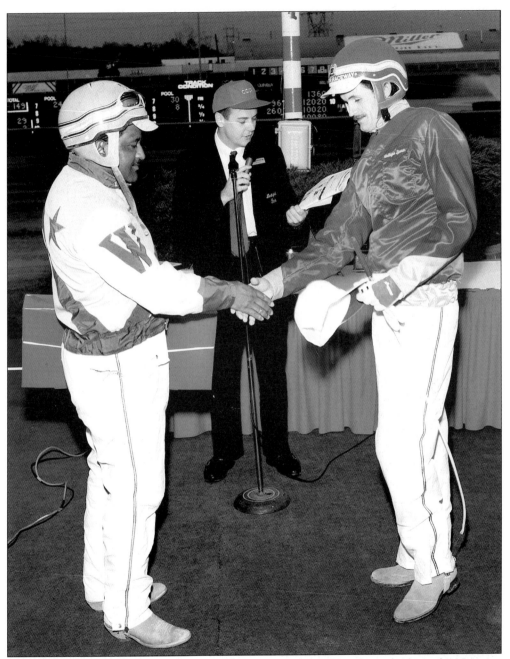

Charlie Williams, brother of Lew, and a fine horseman himself, welcomes Alexander Nessiaev in a winners circle presentation of a Northfield Park cap. In the background is Northfield publicist Ken Warkentin, who went on to fame at the Meadowlands.

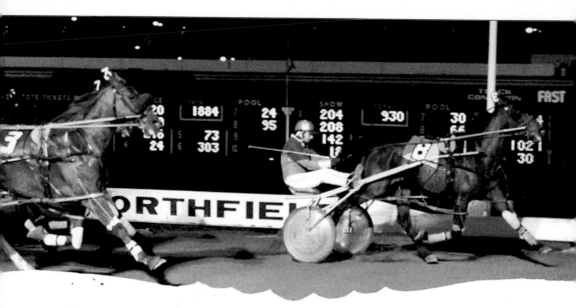

Northfield Park

PLAZA JESTER

DRIVER-GENE DUPLAGA
TRAINER-K. GISSER
LESSEES-KEN KOSTAR & KEITH GISSER
PURSE $1,900 - APRIL 20, 1979

MIKE A BREEZE 2ND
WALTONA MEDOTIME
3/4 MI PACE 1:34.

In the late 1970s, and then on and off throughout the years, the track has contested odd-distance races. Here is the author's Plaza Jester ripping off a win in a three-quarter mile (six furlong) dash in 1:34.4. In the winter and spring of 1979, nearly all of the claiming races were carded at odd distances, from one-half mile to a 1/16 miles.

THREE

The Horses

Talk to any racing fan and he is far more likely to remember a specific horse than a specific driver, mutuel teller, or clubhouse waitress. It's ironic, because the standardbred is a pretty homogenous breed—the vast majority being brown or bay, with the occasional chestnut or gray thrown in. Nonetheless, the racing fan talks about a horse in a specific race or watching him grow up throughout his career.

Northfield has seen many of the greatest in the history of harness racing over the years. Horses like Whata Baron, Pickwick Baron, Missouri Time, Osborne's Bret, Mary Mel, New Deal, Majestic Osborne, and Le Mistral raced the majority of their careers here. Pacers Abercrombie, Nero, Silk Stockings, Au Clair, Precious Bunny, Artsplace, Life Sign, Western Hanover, Western Dreamer, and Nat Lobell have raced here over the years. So have World Champion trotters Green Speed, Editor In Chief, Mack Lobell, Grades Singing, Sturdy Lori, Blastaway Sahbra, and Dunkster. Many of these top stars are portrayed in this chapter, but not all. In fact, we could easily do a whole book on the equine stars of Northfield Park. Unfortunately, the reader will need to settle for one chapter.

Canadian star Joe O'Brien, and star pacer Nero jog free-legged (without hopples) at Northfield Park. Nero faced off against several top horses at Northfield over the years, most notably Wall of Famer Whata Baron.

Lord Gene was a decent pacer of the early 1970s, despite missing three years to injury! He was very simply rigged for his time. He wore a Kant-See-Back bridle (shown), with a plain snaffle (jointed) driving bit. The smaller bit on the bridle being held by Robert Field is an overcheck bit. It attaches to a "check rein," a strap that goes over the head and attaches to the top of the harness to help a horse keep his head at the proper height.

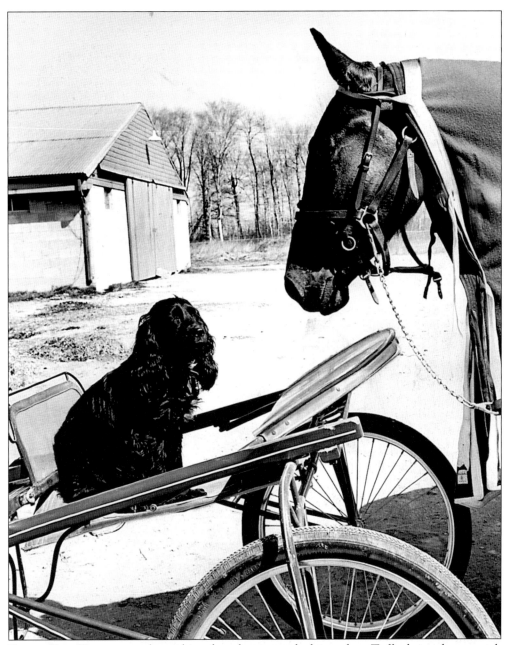

Trotter Don K appears to be wishing for a better catch driver than Tuffy the cocker spaniel. The accompanying caption for this 1962 photo says that horses and dogs often form strong attachments, but ironically dogs are not allowed in most backstretch areas today. Cats are welcome, as they keep the rodent population down and when you have enough grain and hay around to feed the over 750 horses that reside at Northfield Park, it's a good thing those felines are around.

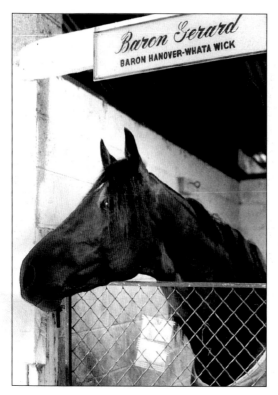

Baron Gerard was the older brother of the great Whata Baron. A foal of 1969, he raced until he was nine, banking just under $380,000 in his career. He held the track record at Northfield for a time in 1973 and to this day he and Whata Baron are the only brothers to hold the Northfield track record. Their sire, Baron Hanover, was the dominant Ohio sire of his day and was a full brother to the great Bret Hanover.

Many excitable horses share their quarters with goats. Having a goat around seems to calm the horse, in this case Time Chief. Apparently having Butch the goat around didn't help much, as Time Chief made under $18,000 in his short racing career.

Honest Story set a divisional track record at Northfield in the 1967 Grandview-Ohio Futurity, pacing a 2:01 mile, best ever by a three-year-old pacer at the time. Eddie Cobb drove Honest Story, who is shown here with his caretaker Willie Hargrove. A son of Adios Butler, at the time the fastest pacer ever, Honest Story went on to a successful career as a stallion in Ohio.

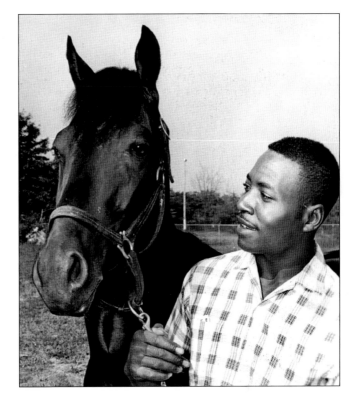

The ill-fated Lavender Laddie paced the first "Miracle Mile," a mile under two minutes, in Northfield Park history when he posted a 1:59.1 mark on June 4, 1970. He then went east and faced the best in the sport, but became mysteriously ill prior to a race and was shipped back to the Midwest where he died at age four. Rumors flew that he had been poisoned, since the big boys on the East Coast couldn't beat him on the racetrack, but nothing was ever proven and the Wood family, who campaigned him, have never commented.

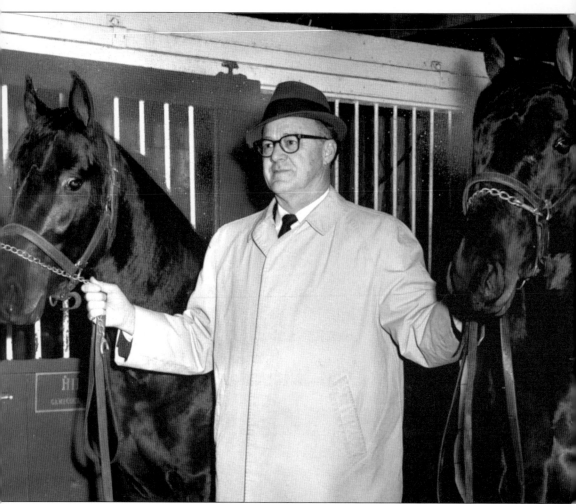

The broodmare Jane Brewer pretty much made the career of trainer Earl Bowman. As the private trainer for owner Elbridge Moxley, shown here, he trained all of her offspring. About Time, on the left, is a Northfield Park Wall of Fame member from the class of 1992. But He is one of 16 foals of the mare, all of which got to the races. About Time took a mark of 2:00 in 1968 and earned $160,000. His brother, All Time, also shown, was Jane Brewer's fastest foal, taking a mark of 1:57.4. Her final foal, Breta Jane, was foaled in 1978, meaning Jane Brewer missed getting in foal just once. She is arguably the greatest broodmare in Ohio racing history and nearly all of her babies started their careers at Northfield Park.

Gene Riegle (right) and Jay Time are pictured here. Riegle, a member of the Harness Racing Hall of Fame in Goshen, New York, is a native of Greenville, Ohio. He has won multiple national driving championships and trained (among others) Artsplace, Life Sign, Western Hanover, and others, including former Northfield Park track record mare Leah Almahurst. His chartreuse and red colors graced Northfield on many occasions, both in open Stakes and Ohio Sires Stakes competition. His sons Alan and Bruce remain very active in the sport

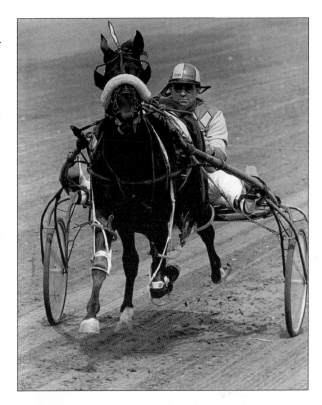

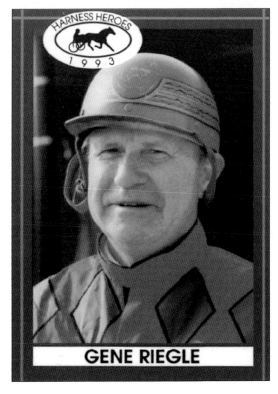

The Harness Horse Youth Foundation began their Harness Heroes collectors' cards in the early 1990s. This is Gene Riegle as he appeared in 1993, just after being inducted into the Hall of Fame. Now 76, he remains active in the sport and can be seen at nearly every major event. The cards continue to trade briskly on eBay among collectors and featured both modern and historical figures in the sport.

The pacing mare Brets Pet was a top mare of the early 1970s, going on to bank over $173,000 for the Latessa family of Wickliffe. That's Lisa Latessa looking thoroughly bored with the photographer in this 1972 picture.

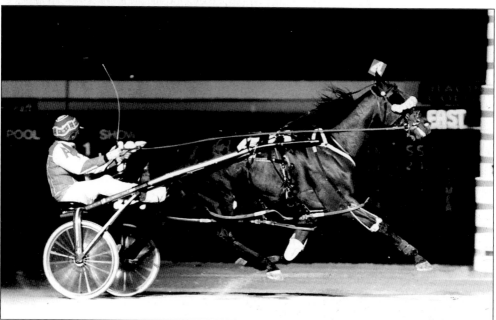

Majestic Osborne, or Sam, as he was known to his fans, was based at Northfield for owner Jerry Osborne of Mentor, Northfield's First Distinguished Owner (1990). Majestic Osborne is the only four-time Ohio Sires Stakes champion, winning in 1991 at age two, as a three-year-old, and winning the veteran titles at four and five. A gelding, he retired from racing in 1997, winning 47 of 98 career starts, for a remarkable 48 percent win rate over five years! In 1994, he joined his trainer/driver Joe Adamsky (1993) on the Northfield Park Wall of Fame.

Baron Real was a hard-knocking campaigner of the 1990s who traveled throughout Ohio, Western New York and Ontario. With his tongue out, he appears to have wanted two lumps of sugar with his tea. This hardware was typically given to winners of mid-level stakes races in the 1960s and early 1970s.

Great Pleasure wasn't a great mare, but she was a good (and unusual) one. A 1956 daughter of Hodgen, from the Adios mare Pleasant Surprise, she raced on both the trot, where she made over $100,000, and on the pace, where she earned a respectable $42,000. Double-gaited horses are very rare, since the movements and muscles for the two gaits are so different. Pacers move both legs on the same side at the same time, while trotters move opposite legs—right front and left rear—simultaneously.

51

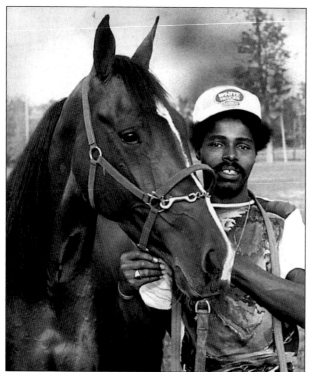

To this day, Silk Stockings is not only the greatest race mare in the history of harness racing, but also one of its greatest stories. Owned by Ken and Claire Mazik and handled by Preston Burris, the mare's earning helped support the Au Clair School for Autistic Children. She is shown with caretaker Butch Wisher. Silky came to Northfield twice in 1977, winning both races.

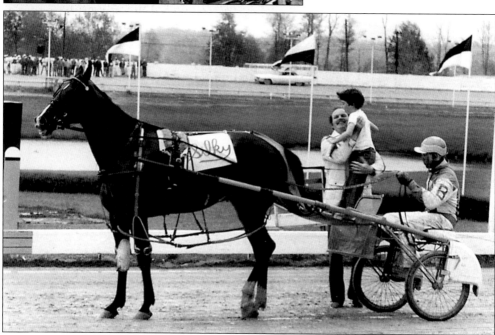

"Silky" was followed for most of 1977 by a CBS 60 Minutes camera crew. She made numerous publicity appearances, including this AM foray at Northfield. In her second Northfield start of the year, she barely edged out local favorite Missouri Time in front of a huge crowd. The race aired on 60 Minutes as part of a profile of the mare and her charitable work. Unfortunately, plans for a feature film on the great pacing mare never came to fruition

Big O Hanover raced in the Battle of Lake Erie at Northfield Park in 1972 for Archie McNeil and Osborne Farms, the *nom de course* of Jerry Osborne. It wasn't until after the Battle of Lake Erie was made Northfield's centerpiece race, in 1986, that folks realized the name had been used for a series at the track in the early 1970s. You can easily see the equipment he wore—bell boots, knee boots, and hopples (the straps around his legs), a full shadow roll under his eyes and a blind bridle.

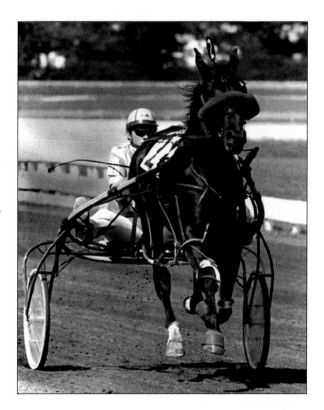

Bob Eidens bathes a horse after a workout. After exercising, horses cannot just be tossed into their stalls. They are bathed, and depending on how hard they worked and on weather conditions, walked as they cool down, just as it is suggested that human athletes should cool down after exercise.

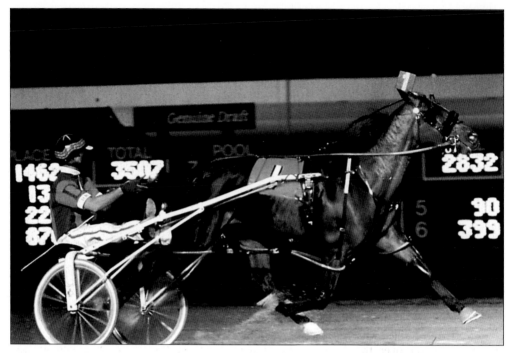

Body By Sam was Northfield's Horse of the Year in 1998. She was one of a long line of outstanding mares that campaigned at Northfield. In fact more mares have been named Horse of the Year at Northfield than male competitors. They include Sue's Misty in 1992 (pictured below with trainer Kelly O'Donnell driving); Shanny Osborne in 1994; Body By Sam (shown with Don Rothfuss in the bike); Stinging Scooter in 2002; Cam's Valentine in 2003; and Midnight Jewel, who shared the honor with Cambest Prince in 2003.

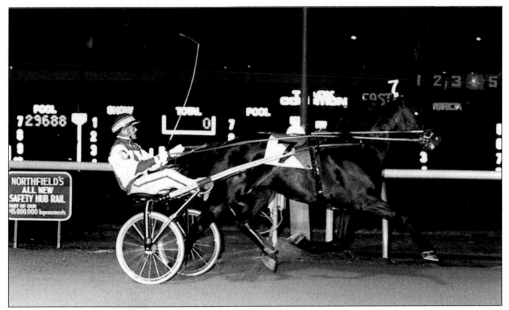

The great Mack Lobell, with the incomparable John Campbell in the bike, made one visit to Northfield Park and left with the track record. His 1:58.4 mile on April 25, 1988 was the fastest ever by a trotter over the Flying Turns. Chuck Sylvester trained Mack Lobell for the controversial Lou Guida and One More Time Stable. Northfield veterans will chuckle at the sign touting the safety hubrail in the background. Although part of a $5,000,000 renovation of the track, it was considered extremely dangerous by horsemen due to its height, and was removed after a short period. They referred to it as the killer hubrail.

In August of 2003, Allamerican Captor equaled the World Record with his 1:50.2 win in the $200,000 Miller Lite Cleveland Classic at Northfield. The Captor was driven by former Northfield driving champ Brett Miller and trained by former Northfield conditioning titleist Virgil Morgan Jr. David Rahal, and Alvin Jacobson share ownership of Allamerican Captor.

Good Humor Man was the most expensive standardbred yearling ever sold at public auction when Vernon Gochneaur of Aurora, Ohio purchased him for $210,000 in 1971. It was a record that stood for many years. Unfortunately, he earned only $9,075 in his career and took a race record best of 2:03 at Northfield during his three-year-old season.

FOUR
The Races

The centerpiece of Northfield Park's current stakes schedule is the Battle of Lake Erie, a rich free-for-all pace that has attracted Triple Crown winners, past and future Horses of the Year and World Champions. It is accompanied by the Miller Lite Cleveland Classic for three-year-old pacing colts, the Courageous Lady for three-year-old pacing fillies and the Scarlet and Gray Stakes for veteran Ohio-bred pacers and trotters. Northfield also alternates as host of the $1,000,000 Ohio Super Night with Scioto Downs, near Columbus.

Those races, initiated in the 1980s and early 1990s, built on a long tradition of top races at Northfield. The track initiated the Walter Michael and Charles Otis Paces and hosted numerous barnstorming series like the Harness Tracks of America and Can-Am Pace. The track hosted the last match race in Ohio, between Mary Mel and Au Clair and has also used special celebrity races and all-female driving events for promotional purposes.

Whether the purse is $200,000 or $2,000, the thrill of hearing that the horses are, "on the turn and heading for home," is still one of the most exciting things a race fan can experience.

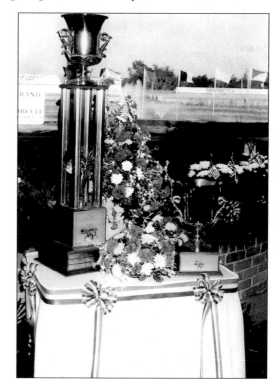

Northfield Park's most prestigious race is the Battle of Lake Erie, with the trophy shown here. Among the great champions engraved on it are Falcon Seelster, Jaguar Spur, Dorunrun Bluegrass, Arrive At Five, Western Dreamer, and Gallo Blue Chip.

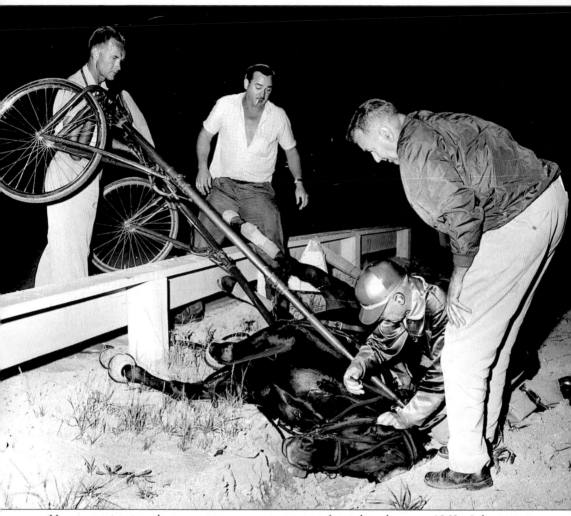

Harness racing is a dangerous sport, as you can see from this photo, c. 1962. A horse going downs is always dangerous, but going over the hubrail is even worse. The key is to keep the horse on the ground until the sulky is unhitched. This low hubrail isn't nearly as bad as the so-called killer hubrail show on page 55, but the so called Euro Rail track design of the modern era—which uses pylons, rather than hubrails—is far and away the safest option. You will see the pylons in the modern era photos of Northfield Park throughout this book.

The 40th Anniversary Challenge race on August 23, 1997, pitted drivers who competed during Northfield's opening season. It capped a huge celebration that included an antique car cruise-in, sock hop, and the chance to win $40,000. The race featured, from left to right, Joe Adamsky (with his back turned), Earl Bowman, Bill Popfinger, Tom Brinkerhoff, Dick Brandt (being interviewed), George Ursitti, and Ted Taylor (behind Brinkerhoff). Northfield's Director of Racing Gregg Keidel is interviewing the legends.

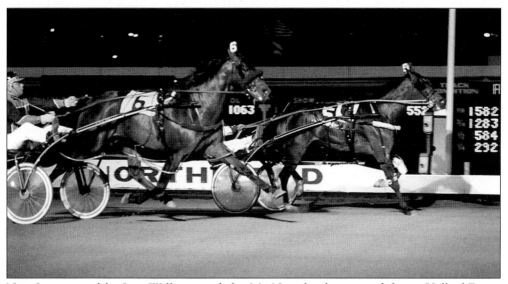

New Lew, owned by Lew Williams and the Mc New family, stunned future Hall of Famer Abercrombie and driver Glenn Garnsey in the 1979 Walter Michael Memorial Pace. Lew's older brother, Charlie, drove the son of Breadwinner, although there was controversy over his breeding in the days before blood typing. Many believed he was actually a son of Whata Baron, who had the same connections.

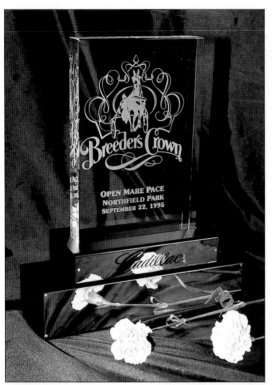

It all comes down to the Breeders Crown and Northfield has hosted six of the championships. This is the trophy for the 1995 Open Mare Pace, won by Ellamony. Also on that night, That'll Be Me shocked everyone except the author with a win in the Open Pace at odds of 10-1. The track hosted two BC races in 1992, when Kingsbridge took the three-year-old colt title and So Fresh won the filly championship.

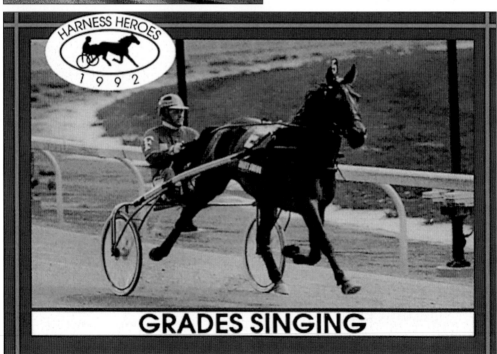

GRADES SINGING

Grades Singing, shown on her Harness Heroes 1992 trading card, won the first Breeders Crown at Northfield, taking the $228K Mare Trot in 1989. She returned from Europe with Swedish trainer/driver Olle Goop to defend her 1988 title in a track record time of 1:58.3.

The Armstrong Brothers dominated Ontario harness racing for years as the foremost breeding farm in Canada. They sent Armbro Feather to Northfield in 1989 to defend her Breeders Crown title as the best veteran pacing mare in the sport. John Kopas drove the millionaire mare for trainer Jack Kopas, his father.

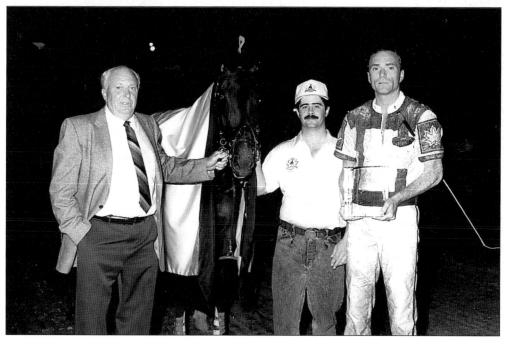

A muddy John Kopas is seen in the winners circle with Armbro Feather, her caretaker, and Charles Armstrong after her track record 1:56 mile.

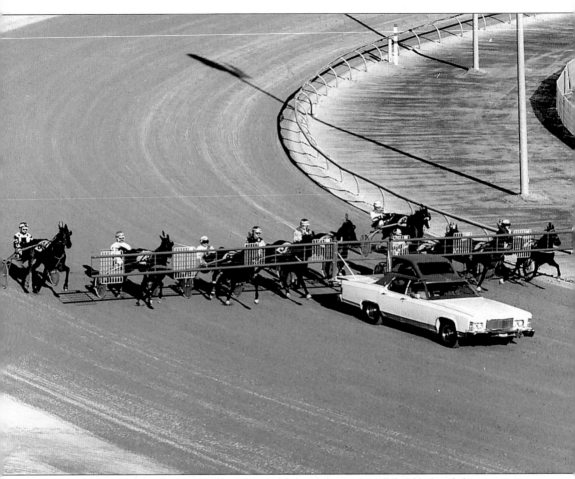

There's the killer hubrail again. Here you get a good view of a full field behind the starting gate. By rule, horses must be within one length of the gate at the start, or the horse's driver may be fined. Northfield starts (or scores) eight across the track, so the exception is for horses nine, ten, and eleven. A typical race has nine starters and the nine usually starts behind the one, although he may start from behind any of the front tier of horses.

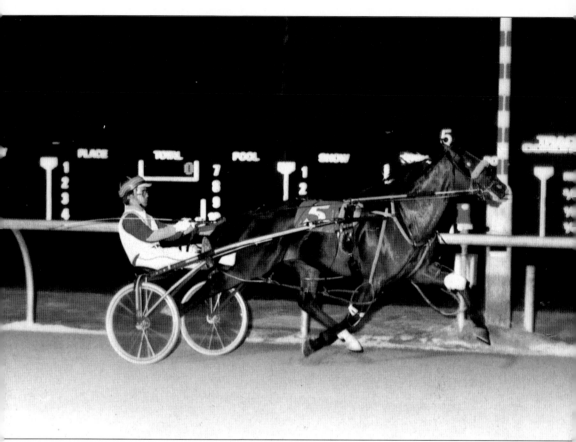

Jaguar Spur and Dick Stillings became the first horse and driver tandem to take the Battle of Lake Erie twice, although he benefited from a disqualification in his 1989 win, when Matts Scooter interfered with him at the three-quarter pole. Owner Ray Davis named all of his horses Spur in honor of British soccer club Tottenham Hotspur.

The Battle of Lake Erie is a huge event for Northfield, consistently drawing the largest crowds of the year. Part of the reason is the aggressive promotions tied to the race. In 1991 and 1992, patrons received a set of four commemorative glasses with paid admission, a promotion that was repeated in 1999. Boxed sets of the glasses, valued at $10, have sold for over $30 to collectors!

In 1991, patrons had the option of a stylish Battle of Lake Erie T-shirt or a set of glasses. Always looking to curry publicity favor, media members got golf shirts, as shown on the left.

The Battle of Lake Erie theme carries on throughout the week, as seen in this table setting for the Battle media luncheon, which includes the ceremonial post position draw for the eight invitees.

Director of Racing Gregg Keidel (left) hosts the Battle of Lake Erie Press Conference. Associate Judge Larry Willis (center) and Presiding Judge Mike Hall join him. As with any race, the judges supervise the post position draw. For the Battle, media members drew the post positions for the horses, up until 2004, when patrons were selected for the honor.

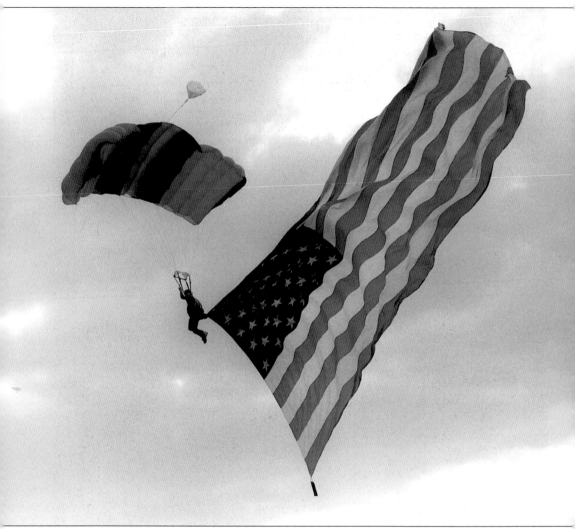

A grand entrance kicks off Battle of Lake Erie night. Here the American Flag is delivered by a skydiver prior to the rich battle race card. The race is named for a battle in the War of 1812, when nine small American ships, including Commodore Oliver Jazard Perry's brig *Niagara*, defeated a squadron of British ships near Put-In-Bay, Ohio.

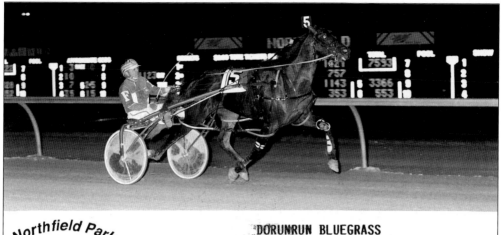

Northfield Park

Every 19 Minutes, The Place Goes Crazy!

PHOTOS BY LINSCOTT PHOTOGRAPHY

DORUNRUN BLUEGRASS

OWNER: LUEL P. OVERSTREET, HENDERSON, KENTUCKY JUNE 2, 1990

DRIVER: HERVE FILION TRAINER: JOHN MERKEL

PURSE $100,000 BATTLE OF LAKE ERIE **BATTLE RECORD**

FREE FOR ALL PACE 26.4 56.2 1:25.2 **1:54**

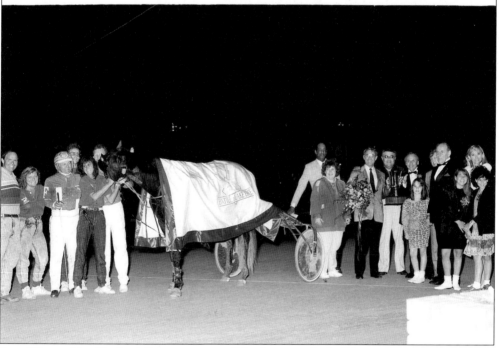

Proud Kentuckian Dr. Luel Overstreet tags all his horses with the Bluegrass moniker, and none was better than Dorunrun Bluegrass, who won the 1990 Battle of Lake Erie with Herve Filion in the bike. Dorunrun was trained by John Merkel who is standing behind the trophy, between Overstreet and Northfield President Myron Charna. His one-mile time of 1:54 set a Battle record.

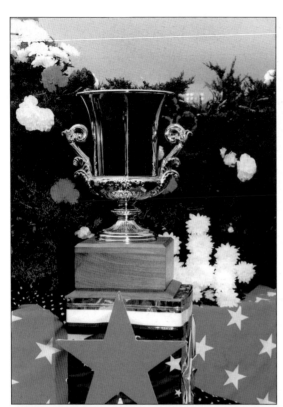

Here is a close up of the Battle cup, which goes to the winner. A large permanent trophy stays on display in the Northfield Clubhouse, immortalizing all the winners.

The odds were in favor of Odds Against in the 1992 Battle of Lake Erie. Steered by Hall of Famer Michel Lachance, he easily won the race in 1:53.1

Local favorite Lusty Leader pulled an upset in the 1995 Battle. Owned by Ted and Tonia Parker of Elyria, Ohio, he was driven by local pilot, Joe Essig Jr. Lusty Leader was a true Cinderella story. The father-daughter team purchased him for just $3,000 after he suffered an injury as a youngster.

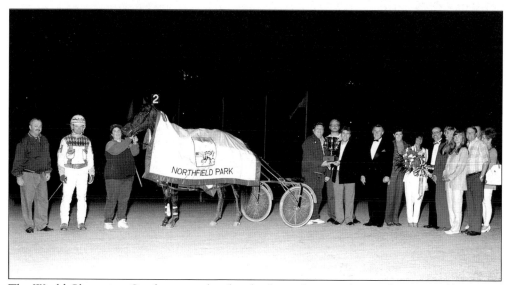

The World Champion Cambest—to this day the fastest horse in history by virtue of his 1:46.1 Time Trial at Springfield, Illinois in 1993—also won that year's Battle of Lake Erie, setting a 1:52.3 track and stakes record. Wally Hennessey drove Cambest, who went on to even greater stardom as a sire.

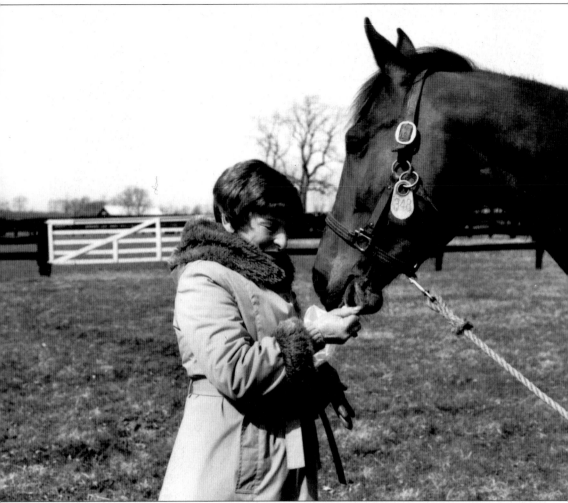

The Courageous Lady Pace, originally contested at Monticello Raceway as the Lady Catskill, came to Northfield in 1990. It annually assembles a group of the sport's top three-year-old filly pacers. The race honors one of the finest and most popular fillies ever to race at Northfield Park, Courageous Lady, and also serves as a tribute to her owner, Ruth Cohen. The poignant story began in 1977 when Julian Cohen, a Cleveland attorney and avid harness racing fan, paid $35,000 for the two-year-old filly Courageous Lady as a gift for his sister Ruth, who had been diagnosed with terminal cancer and given less than two years to live. "We bought Courageous Lady midway through her two-year-old season and Ruth loved that horse," said Mr Cohen. "We followed her to all of her races and Ruth lived another eight years, primarily because of that horse."

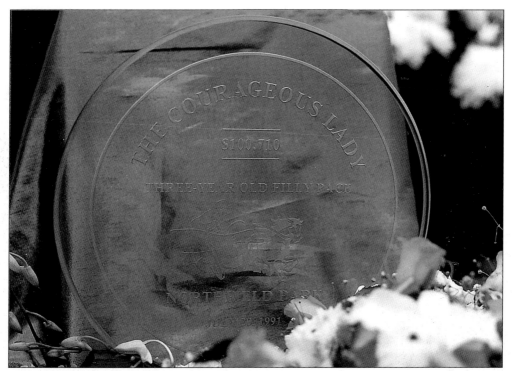

This is the 1991 Courageous Lady Trophy; it was the second edition of the race and was won by Yankee Co-Ed and "Bib" Roberts.

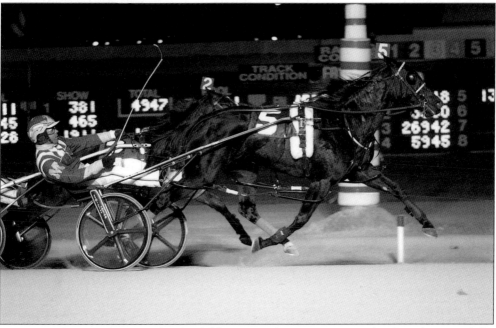

C.C. Spice became the first Ohio-bred filly to win the Courageous Lady when she turned the trick in 2003. Brett Miller drove the winner to 1:53.3 on a cold November night for trainer Rob Harmon and owner Chuck Campbell, a bowling alley entrepreneur from Michigan.

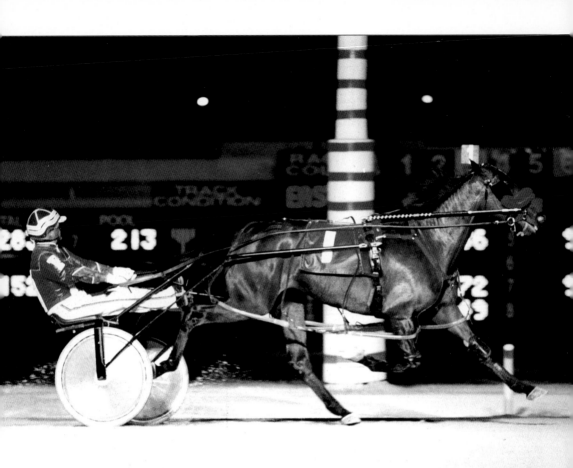

Panhattan won the 1994 Courageous Lady, the only one to be raced in eliminations and a final. Panhattan was second behind Dawn Q in her elimination race, but when Dawn Q scratched from the $84,000 Final, she edged her stablemate Petite Pan to get the win for driver Herve Filion. Filion was so effusive in the post race interview that he talked right through the next race's post parade, forcing the video department to kill his microphone mid-sentence. Filion remains the winningest driver in North American harness history. Still active today, he has over 15,000 victories, making him the most successful professional athlete in North America.

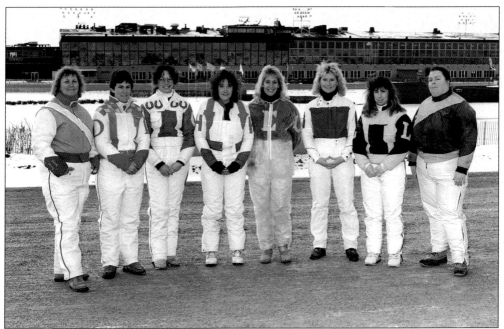

Here is the field for the 1993 Sweetheart Pace, held on Valentine's Day. Pictured, from left to right, are Janet Irvine, Dee Hotton, Barbara Lewis, Sheri Hersman, Debra Eidens, Andrea Miller, Linda Urban, and Kathy Ryan. Hersman won the race and also holds the record for highest win price ever paid at Northfield. She drove Jets Appearance to victory on August 22, 1988 and he paid $579 to win!

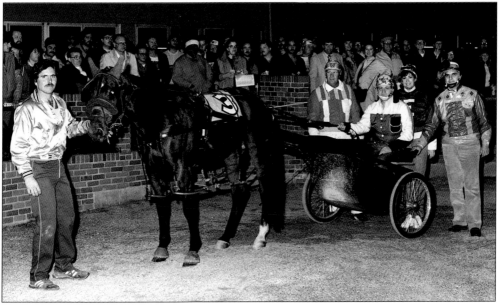

Celebrity and media races to benefit charity played a major part in Northfield's promotional schedule through the years. The amateurs were always accompanied by professional drivers in specially designed two-seat jog carts. Here are the contestants in the Hattie Larlham Foundation Pace.

The Battle of Lake Erie night 1996 featured a pair of media races. The author made history that night when he became the first amateur to actually drive his own horse in a celebrity race. Parked to the quarter, he ended up dead last, well behind the field. He is shown here in the winners circle (third from right) along with radio and TV personalities, from left to right, Mike Snyder, Mark Schroeder, Mike Wolfe, Bill Needle, soccer star Tim Tyma, and Chuck Galeti. That's Buzz the Beaver in front. He was the mascot of the Cleveland Lumberjacks hockey team.

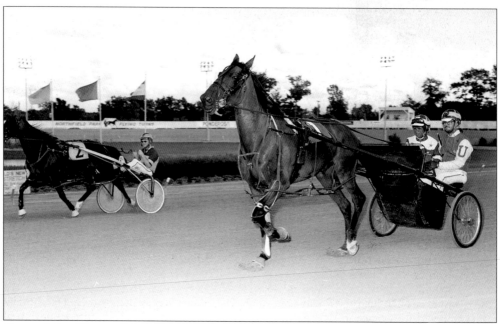

Trainer John Oliverio (No. 2) looks over Clair Umholtz and his Courageous Lady of the media partner in this celebrity race post parade shot.

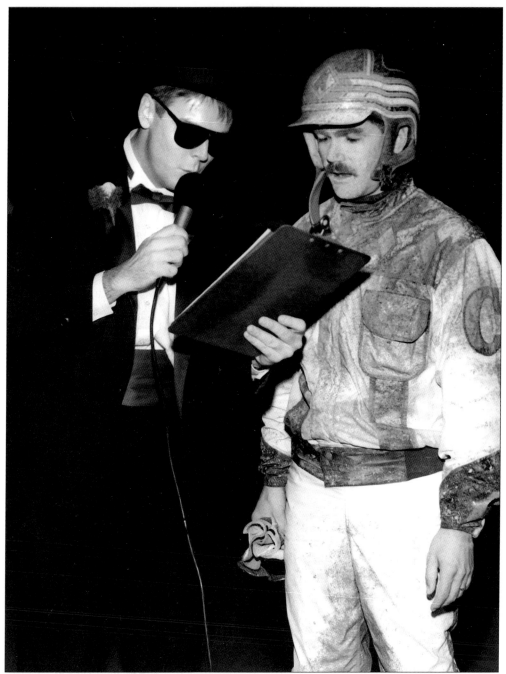

The Cleveland Classic, now sponsored by Miller Lite, debuted in 1990 with two divisions. The first was won by Kiev Hanover, but the star was a colt named Jake and Elwood, which explains the Blues Brothers outfit for the interviewer here. That's a muddy John Campbell who steered the upstart to victory. Jake and Elwood was by the unheralded stallion Samadhi; in fact, he paid a supplemental fee to race in the Classic. His connections accused the top three-year-olds of the year—Beach Towel and In The Pocket—of ducking him all season. Neither competed in the Classic.

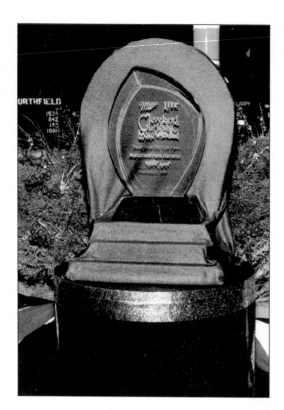

This is the Cleveland Classic Trophy, an impressive display of etched clear silica.

John Campbell was back in the Classic winners circle in 1993 with Little Brown Jug champ Life Sign and trainer Gene Riegle.

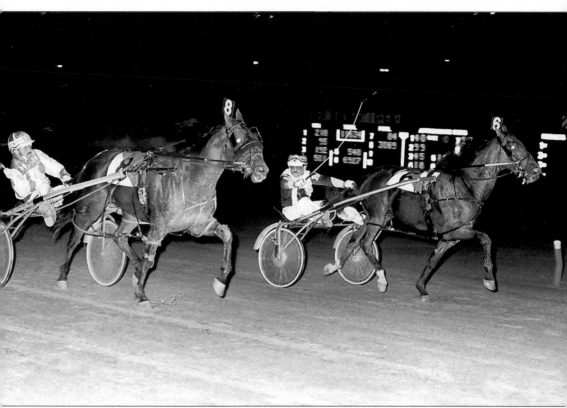

The most memorable Cleveland Classic of all was the epic 1991 duel between Little Brown Jug champ Precious Bunny and Artsplace. Artsplace skipped the Jug due to illness, but many thought trainer Gene Riegle was ducking the East Coast speedster. The two went head-to-head three weeks later on a sloppy track and dominated the field, resulting in one of the most memorable race calls in Northfield, if not harness racing history. As the pair opened up on the field, Greg Young called it, "Precious Bunny and Artsplace...Artsplace and Precious Bunny...Precious Bunny...For the Money." Jack Moiseyiev drove the winner, while John Campbell drove the place horse.

As always, the group sales department at Northfield, headed by Wall of Famer Mary Randall, decks out the facility for major events like the Classic.

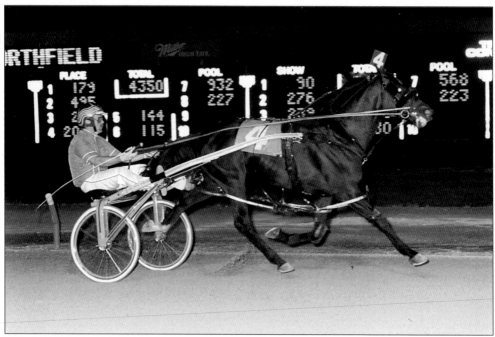

Bill Fahy drove Western Hanover, yet another Gene Riegle-trainee, to victory in the 1992 Cleveland Classic. Five years later, Triple Crown Champ Western Dreamer won the Classic, making them the first father-son pair to win the same major Northfield stake.

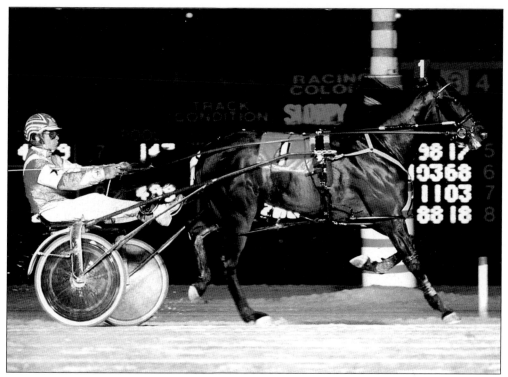

You saw the father on page 78, here is the son. Western Dreamer won the 1997 Classic, after becoming just the eighth pacer in history to win the Triple Crown. Western Dreamer returned the next year and won the Battle of Lake Erie, making him the first to pull off the Classic-Battle double in consecutive years.

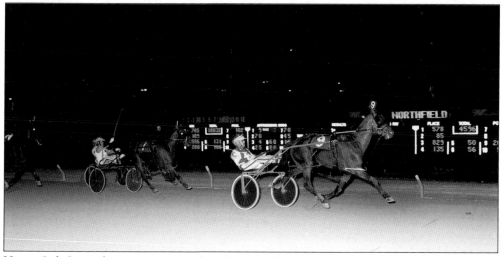

Here is Life Sign's dominating win in the 1993 Cleveland Classic. That's John Campbell driving.

The Charles Otis Pace was a centerpiece stake at Northfield in the late 1960s and early 1970s. As it grew in stature, so did the size of the trophy. Here is Jackie Caughron of Cuyahoga Falls, showing off the 1969 hardware.

The 1970 Otis resulted in the first Miracle Mile at Northfield when Lavender Laddie (page 47) won in 1:59.2. Here, a bevy of beauties from across Ohio, including Miss Ohio Kathy Baumann and five contenders for her crown, show off the large permanent Otis trophy.

Akron's Amy Coleman has her hands full hanging on to the trophies for the 1971 Otis Memorial. She is standing on the backstretch of the track, with a good view of the grandstand behind her.

Bobby Altizer gets dressed for work in 1966. The daily grind of a harness driver/trainer was featured in the *Plain Dealer's Sunday Magazine* in April of 1966. Note Altizer's colors. Today most drivers wear a one-piece jumpsuit, although some opt for separate "whites," which can be white denim, nylon rain pants, or lightweight nylon dusters and a "colors" jacket, with varying weights and lining depending on the temperature.

FIVE
The People

A racetrack is only as good as its people. Drivers, trainers, owners, caretakers, employees, and patrons all come together to create an interesting dynamic with common interests—putting on the best possible racing. Northfield has had some of the finest in the business on both the front side (office) and the backside (horsemen).

The public sees just one side of the harness driver or trainer's life. The races start at 7:00 PM, they end at 11:30. He must only work 4 1/2 hours a day. Sure. Most horsemen start their day at about 7:00 AM, feeding their horses, with the first of their charges hitting the track to jog at about 8:00 AM. The whole barn gets out and by the time the equipment is cleaned, it's about 1:00 PM. Maybe a couple hours for a nap and errands, then back to the track at 4:00 PM to feed and start prepping horses for the races, with the first of them warming up as early as 5:30. That is assuming none of the horses have to be shipped—that there is no county fair racing that day—and that's if the vet and the blacksmith are all running on time.

Roger Hammer is making sure that Flashy Filly is comfortable around this young goat. This photo identifies Roger as the "son of Clay Hammer." Roger ended up being much more than a kid playing with a kid. Clay and Roger are the only father and son team to take multiple National UDRS "Batting Average" Championships. Clay won the title in 1968, '74, '77, '78, and '79. Roger won it in 1981, '82, '86, '87 and '88. Roger continued to race at Northfield in stakes events well into the new millennium.

Drivers, male or female, are far more likely to be applying lip balm than lipstick, but that didn't stop a 1971 photographer from staging this scene of Carol Huckill getting ready for the races. Although the number of female drivers and trainers is small, there have been many talented distaffers competing at Northfield through the years, and the majority of caretakers are female. Northfield has been home to a number of female trainers and drivers, including Jeannie Budalan (Smith), Mary Irvine, Janet Irvine, Mary Schreck, Dee Hotion, Kim Sloan, Eldine Elmore, Sue Kovack, and Bridgett Nappi.

Mary Schreck had a small, but successful stable at Northfield in the late 1970s. The author regularly raced against her and found her abilities to be exceptional. This is her star pacer Ideal Sam.

Wooster's Dee Hotton is another trainer with a small but very competitive stable. She is shown with her open pacer Magnificent Mel, but may be better known for her work with the top trotter Glory Bound, who she raised from a baby. He has earned over $300,000 and continues to race.

Top left: The Irvine family has become synonymous with racing at Northfield Park. Although Don Irvine Sr. passed away a couple years ago, his children, Bill, Janet, and Don Jr., continue the tradition, as do grandsons Brad and Wyatt. This is Bill Irvine, a former all-conference quarterback at Mt. Gilead High School. He is an outstanding conditioner of young horses and was named to Northfield's Wall of Fame in 1992

Top right: Janet Irvine, as she appeared in 1974. Janet has maintained a small barn at Northfield for many years and developed a reputation as a good trotting trainer.

Don Irvine Jr., shown in a 1976 photo, was voted onto Northfield's Wall of Fame in 1991. He has done most of his racing on the Indiana circuit over the past several years.

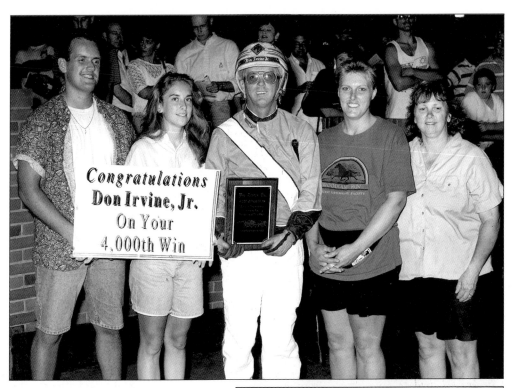

Don Irvine recorded his 4,000th win while racing at Northfield in 1993. That's his son Brad on the right and sister Janet on the left. Brad is currently one of the top drivers at Plainridge Racecourse in Massachusetts.

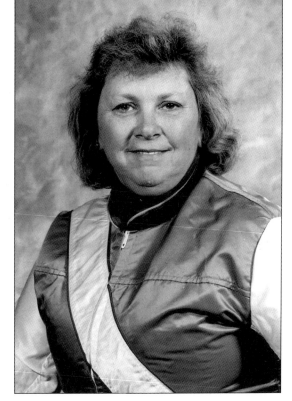

Janet Irvine is seen in the familiar gold colors with the white diagonal and red trim. Each Irvine's colors are slightly different, as required by U.S. trotting Association policy, but all are similar enough that they can be picked out at any racetrack.

Bob Farrington led all of North America in driving wins in 1961 (201) and 1962 (203). Both were record totals. Farrington raced at Northfield regularly in the early 1960s and is probably best known for campaigning "The Horse that God Loved," Rambling Willie. Farrington also contributed a remarkable chapter on stable management to the original version of *The Care and Training of the Trotter and Pacer* in1968. It should still be mandatory reading for anyone in the business today.

Gerry Bookmyer was a fixture at Northfield Park for over 40 years. He won his first driving title in 1964 and continued to win championships into the 1980s. This is how he appeared when winning that first of eleven titles, in the mid-1960s.

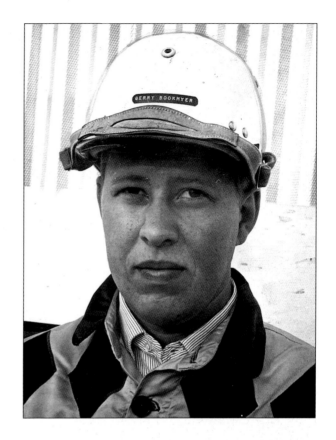

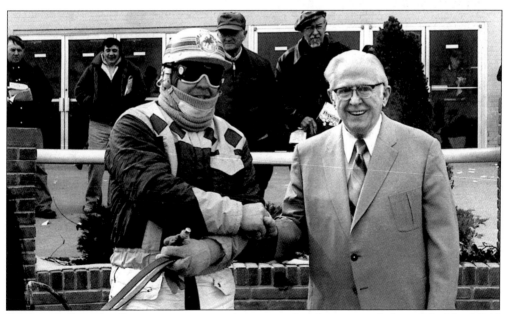

Bookmyer adapted well to winter racing and was named to the inaugural class of the Northfield Park Wall of Fame in 1990.

Two of the greatest drivers in the history of harness racing, Herve Filion (No. 3) and Lew Williams move in behind the gate at Northfield Park. Williams, who died in a tractor accident on his farm while in his prime, is considered the finest African-American driver ever, while Filion, who raced only sporadically at Northfield, remains active well into his sixties. There is no record of what horses they were driving in this 1973 race.

A very young John Konesky III scores the aptly named Leap Year Girl prior to racing in 1970. Leap Year Girl was foaled on February 29, 1964. Konesky was elected to the Presidency of the Ohio Harness Horsemans Association in 2003. He races primarily at Toledo's Raceway Park, near his Pemberville, Ohio home, but often ships here to race trotters, especially in stakes races.

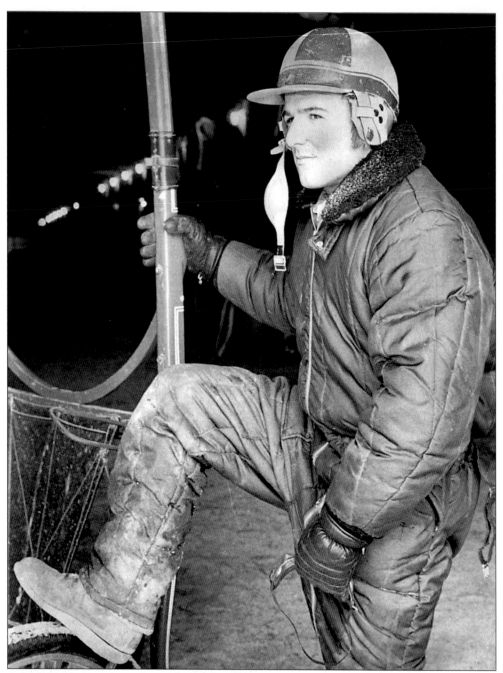

Dale Hiteman began his career at Lebanon Raceway in Southwest Ohio before moving to Northfield in the mid-1970s. He was an in-demand catch-driver as that skill became more and more popular. He moved on to race on the Chicago circuit, where he is still very competitive. At the time this picture was taken, the star of Hiteman's stable was a horse called Trusty Time, a rehabilitated Amish buggy horse who went from maiden races up to open competition at Northfield in a span of a six or seven race winning streak.

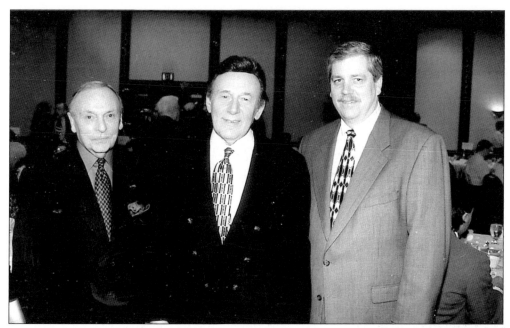

The track became one of the premier facilities in the country under the leadership of owner Carl Milstein (center), President Myron Charna (left), and General Manager Tom Aldrich (right). From the time Milstein regained control of the track in 1985 until his passing in 1999, he invested nearly $20,000,000 in renovations.

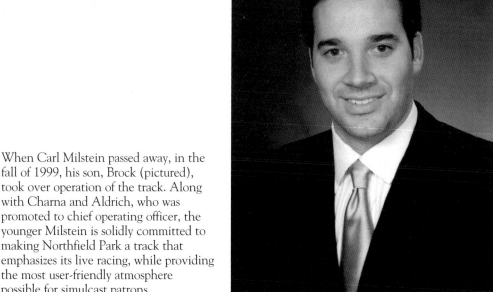

When Carl Milstein passed away, in the fall of 1999, his son, Brock (pictured), took over operation of the track. Along with Charna and Aldrich, who was promoted to chief operating officer, the younger Milstein is solidly committed to making Northfield Park a track that emphasizes its live racing, while providing the most user-friendly atmosphere possible for simulcast patrons.

The legendary Andy Cunningham, the "Golden Voice of Northfield Park," called over 40,000 races at the track during a 24-year tenure, not to mention a dozen other tracks at which he announced. He also served as announcer for Bedford Sportsman Park; the midget auto racetrack that stood on the site before Northfield was built. Additionally, Cunningham did publicity work for the Cleveland Rams of the National Football League and the Cleveland Barons of the American Hockey League. The Euclid native was part of the inaugural Northfield Park Wall of Fame class in 1990.

While Gregg Young may be the current "voice" of Northfield Park following in Andy Cunningham's footsteps, the "face" of Northfield Park is Dave Bianconi. In addition to serving as publicity and simulcasting director at the track, he has worked as an assistant race secretary and shares television handicapping and interview duties with the author. Here he interviews basketball star and horse owner Sam Bowie in the Northfield winners circle.

Bianconi conducts a handicapping seminar for Northfield patrons with controversial leading trainer Bob Belcher. Belcher has conditioned nearly 3,000 winners in the past 15 years and has 8 John Caton trophies as Northfield's leading trainer.

Canton's Don Graham, along with Mentor's Jerome Osborne and Painesville's Robert Sidley, was a dominant horse-owner at Northfield in the 1970s. His partnership with trainer/driver Don Irvine yielded Little Brown Jug starter New Deal, top mares Betty Jo Chris and Super Trip Missy and dozens of others. An astute judge of horseflesh, he didn't need Fleetwood Belgen's help reading the program.

Tom Brinkerhoff continues to compete at Northfield today, well into his sixties. Known both as a conditioner of top stakes colts and as a top driver in his prime, the Wooster native's blue and gold colors were a fixture at Northfield until he moved his base of operations to Scioto Downs several years back. Brinkerhoff was elected to Northfield's Wall of Fame in 1994.

SIX
The Wall of Fame

The Northfield Park Wall of Fame was established in 1990 to honor the human and equine stars of the track. Nominations to the Wall of Fame may be made by fans, horsemen, owners, or media members. A board of trustees meets periodically to consider nominations and to vote on the nominees. To be inducted, a nominee must be one of the top four vote getters in the year he or she was nominated; however, at least one representative from each category, human and equine, will be elected in each election.

The Wall of Fame is located in Northfield Park's clubhouse. A complete listing of Wall enshrinees, along with complete biographies, is available at the Northfield Park website (www.northfieldpark.com). When possible, we have endeavored not to use the official Wall of Fame photos of the honorees in this chapter.

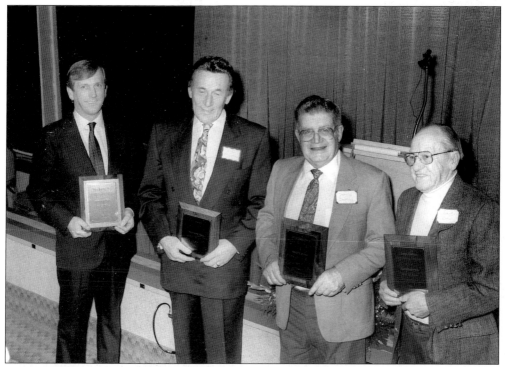

The Wall of Fame Class of 1991, from left to right, is Don Irvine Jr., Carl Milstein, Dominick Staffrey (on behalf of the pacing mare Missouri Time; he would have to wait until 1994 to be elected to the wall), and John Caton.

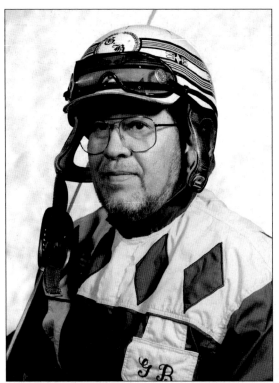

Gerry Bookmyer was elected to the Wall in 1990 as part of the inaugural group that included Lew Williams, Fritz Newhart, Walter J. Michael, and Andy Cunningham and equine honorees Jaguar Spur, Whata Baron, and Doc McBean. "Booky," or the Tiffin Terror, as *Cleveland Plain Dealer* reporter Bill Nichols once called him, set track and world records throughout his career at Northfield.

Jaguar Spur only raced at Northfield three times, but he was undefeated in those starts, including two Battle of Lake Erie wins. The third, a prep race for the Breeders Crown, resulted in a 1:53 World Record over the Flying Turns. Dick Stillings drove the pacer and shared training duties with Charles "Buddy" Stillings. His dam, J D's Bret, was also a star pacing mare at Northfield.

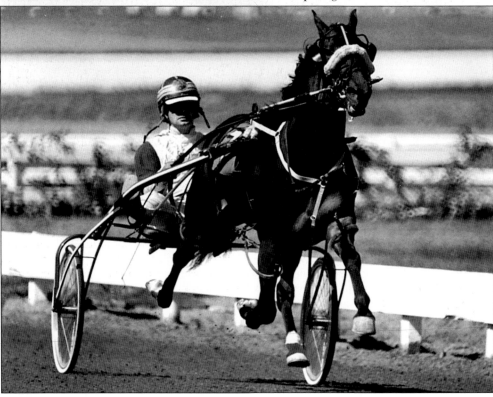

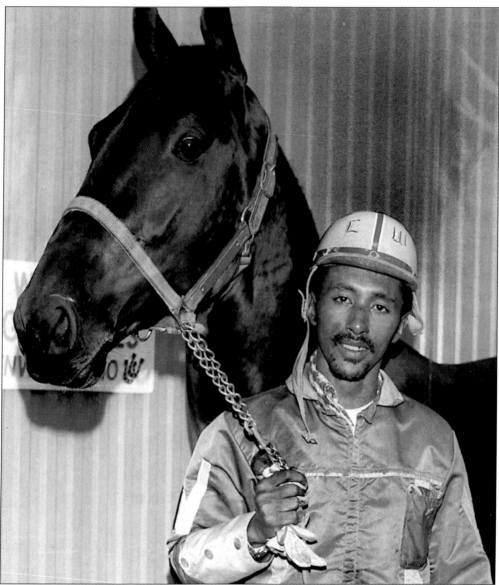

Lew Williams may have been the greatest driver in the history of harness racing. He changed the way the game was played. In the middle of the century, typical harness racing involved a mad dash for the lead and then single file racing until the last quarter mile, Williams often made moves early, forcing other drivers into bad decisions. It is the way everyone drives now, but in the early 1970s, it was unheard of. "Sweet Lew" was also left handed, which meant he whipped differently than most drivers, which often "shook a horse up." He trained many top stars including the great Whata Baron, who joined Lew in the first group of Wall enshrinees; his brother Baron Gerard; the brothers Jilley, Jeckyll, and Jargon; and world champion fillies Real Hilarious and Mary Mel. Mary Mel won a match race against Au Clair, Silk Stockings' stablemate, in the last race of its kind at Northfield on September 16, 1976. He is shown with Amtar Hanover, a career winner of 22 races.

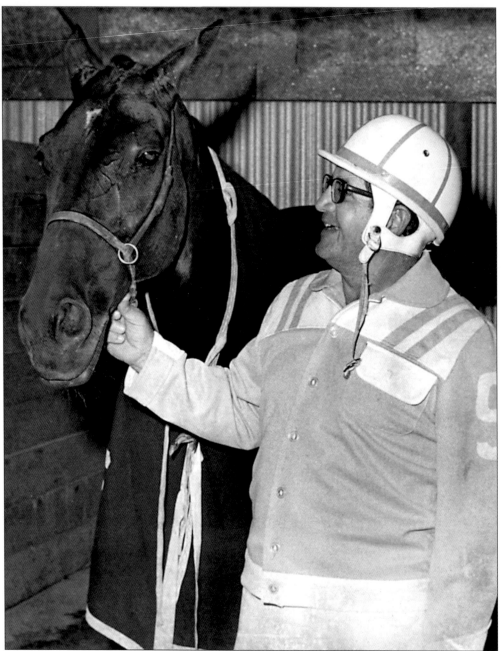

Here is Dom Staffrey with his county fair terror Baron Chuck. Although Staffrey is best known for his work with the World Champion Missouri Time, the Canfield native spent most of his summers racing young horses at the fairs for a variety of owners, most notably John and Florence Vitullo. As a three-year-old in 1977, Baron Chuck won 24 races, just missing the national championship.

John Caton was the first driving champ at Northfield, taking the title in 1957. Born in Moscow, Russia, he was already a seasoned veteran when he came to Northfield. The trainer and driver of such stars as Little Brown Jug entrant Culver Pick and the great Rican Ros, Caton remained active into his eighties, jogging horses at the Lake County fairgrounds nearly every day.

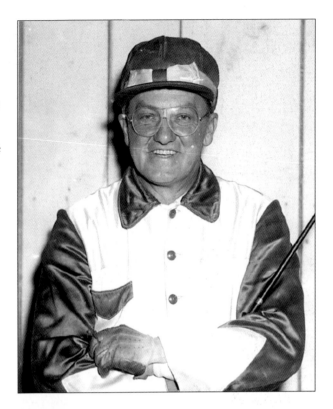

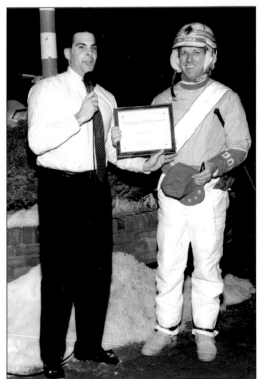

Don Irvine receives one of his numerous driving and training awards from Northfield's Dave Bianconi. This one came in 1996, five years after he was elected to the Wall of Fame. Irvine appears to be laughing at Bianconi's lack of a jacket on the cold March night.

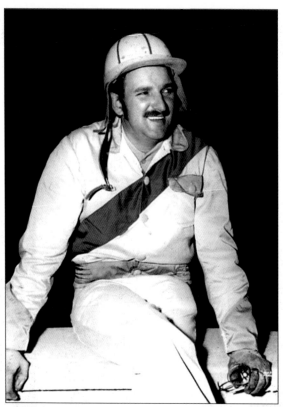

A brash 16-year-old named Don McKirgan made his Northfield Park debut in 1957 and never left. Considered the consummate "Trottin Man," McKirgan also has had success with pacers including Dottie Dart and Winswept Song. He was elected to the Wall of Fame in 1992.

Northfield Park owner and CEO Carl Milstein was named to the Wall of Fame in 1990 and he remained active at the track nearly to the day of his passing in 1999. Here he accompanies Myron Charna (a 2001 enshrinee) as Charna presents the First Northfield Park President's Award to Denise Teeters. Milstein's son and current Northfield CEO, Brock, is in the picture, with Director of Racing Gregg Keidel in the background.

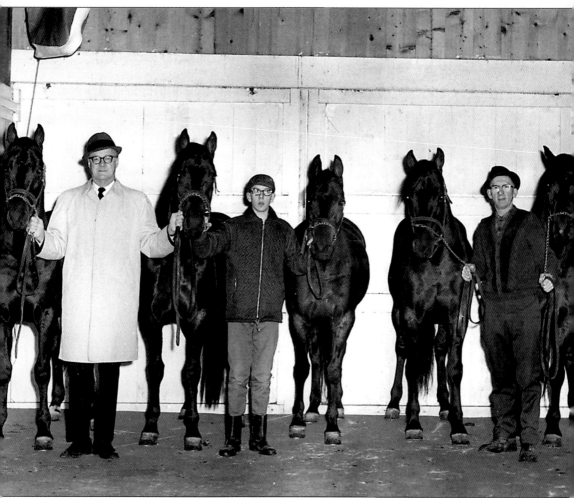

No, they weren't cloning horses in 1968. That's 1993 Wall of Fame inductee, trainer Earl Bowman (far right) with a whole bunch of Jane Brewer's kids, including 1992 honoree About Time (at Bowman's left). Assisting him with Arrival Time, Another Time, Alota Good, and All Time, are his son, Gary, and owner Elbridge Moxley.Broodmare Jane Brewer produced a total of 16 foals. Not only did each make it to the races, they all raced at Northfield. Her first two foals were sired by Good Time, but she had three by Race Time and her final foal, Breta Jane in 1978, was by Bret Hanover. Her legacy continued through her daughters Good Girl Jamie and Good Girl JJ, who were also successful broodmares.

Earl Bowman is pictured as he appeared in the early 1990s. Although a training accident has had him sidelined for most of 2004, Bowman continues to manage a solid stable of horses with the help of his son, Gary, and wife Joanne. The operation is currently headquartered at the Wellington fairgrounds, but continues to race primarily at Northfield.

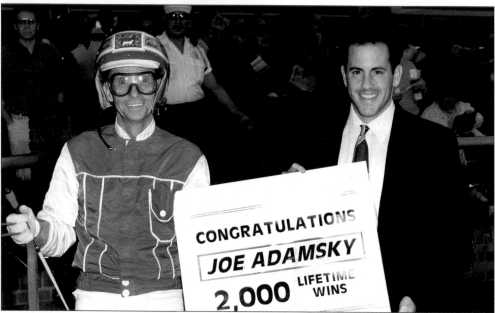

Joe Adamsky was named to the Wall in 1992. He is shown with then-Northfield Publicity Director Joe Dunnigan on the occasion of his 2,000th career win. Adamsky, a master trainer of colts, is best known for his connection to Majestic Osborne, himself a Wall of Fame member, and the only four-time Ohio Sires Stakes champ in history. He also trained the Open Stakes trotter Super Pleasure.

Race secretaries don't get much credit when things go well and take a lot of blame went they don't, but Joe DeFrank is clearly the exception that proves that rule. Inducted to the Wall of Fame in 1994, he is better known nationally as the long time race secretary at a little New Jersey track called the Meadowlands, but he spent at least one meet each year from 1962 to 1977 here. He was one of the innovators of the conditioned/claiming system in use today.

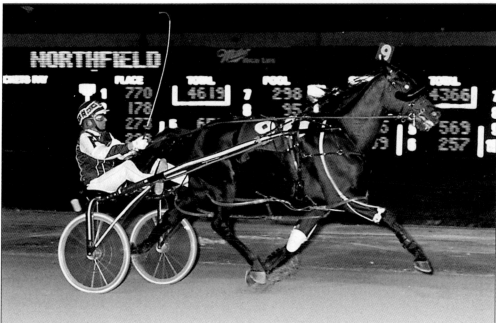

The gelding Majestic Osborne won four straight Ohio Sires Stakes championships from age two until age five, from 1991 to 1994. He earned over half a million dollars for Mentor's Jerry Osborne, racing exclusively in Ohio. He held three different track records at Northfield and was a World Champion.

JH Dandy was a hard-hitting campaigner of the early 1960s, but the story of his trainer driver Mel Dilion is almost as interesting. JH Dandy made it to the Wall of Fame in 1995 on the basis of his consistency, racing against open competition throughout his career. Dilion was deaf, but he had no problem dealing with racing at breakneck speeds behind the star pacer.

Northfield Park's Mary Randall (right) has been at the track longer than the paddock. She directs the group sales department and works long hours on numerous charitable causes. She is popular with customers and her fellow workers—and she didn't pay the author to say that. She was voted onto the Wall of Fame in 1998.

Trotter Independent Blaze joined Mary Randall in the Wall's Class of 1998, as did Ned Bower and Le Mistral. Owned by the McNutts and trained and driven by Jeff Cox, Blaze earned nearly half a million dollars while winning 82 races, most of them at Northfield. He was also a fan favorite, as he participated in the popular piece of a trotter promotion, where racing fans got a portion of his earnings.

Bruce Nickells is considered one of the best trainers of fillies in the sport's history, but he raced regularly at Northfield in the early sixties, taking several percentage driving championships. His Ohio stars included Mr C Song, Batman, Combat Time, and Toodley Du, who he trained for James Michael. His top national fillies included Miss Easy, Central Park West, and Follow My Star. Nickells is "retired" in Florida, but returns to see his daughter, Brooke, and son, Sep, who are active on the Midwest circuit.

Northfield President Myron Charna is part of the most recent Wall of Fame Class, which includes Bruce Nickells, Art Clay, and Mr C Song. Here he surveys the newly renovated clubhouse dining room.

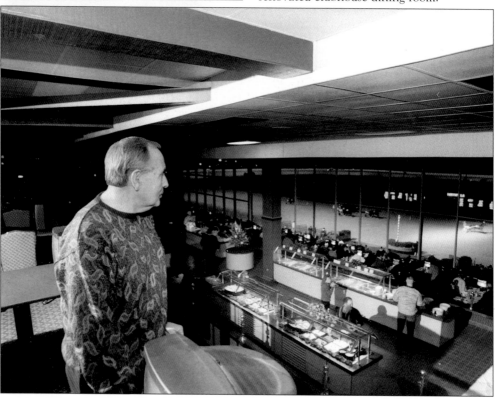

Seven
Northfield Park Today

With the advent of full-card simulcasting, the track spent millions on a complete facelift, adding thousands of televisions, private lighted workstations, or carrels, and in one of the most innovative moves ever, a microbrewery. Carl Milstein knew that for the track to not just survive, but thrive, he would have to appeal to younger crowds and thought the microbrewery, along with simulcast wagering from dozens of other tracks that would allow the place to go crazy every 19 seconds, would be just the ticket.

Business picked up once again and purses went up for the horsemen as well. They continued to rise as handle increased and the track positioned itself to be a strong simulcast partner. An upgrade to the Tote system, including self-service wagering machines and a casino-styled Players Club to reward patrons for their play, one of the first in racing, also helped drive the track to record numbers as the millennium ended.

There were storm clouds on the horizon, however, as the surrounding states increased wagering opportunities through account wagering and slot machines or video lottery terminals. The record numbers leveled off, although the track is still well positioned in the marketplace. Management remains committed to its live product, but saw the writing on the wall, establishing its own account systems: BetHarness.com and BetRunners.com. They caused a short-term reduction in on-track handle, but helped buoy the simulcast numbers, bringing in customers from remote areas by phone and the Internet. While video lottery terminals would help the bottom line immensely, track management continues to promote its racing product heavily, showing its commitment to horsemen and fans.

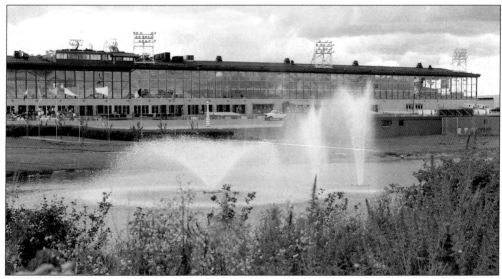

Northfield Park as it appears today from the backstretch. The infield pond contains bass, bluegill, catfish, and snapping turtles, although nobody seems to know where they came from. It also is home to a huge flock of geese and the occasional heron, coyote, or muskrat.

Although the general exterior of the track hasn't changed much since the 1970s (above), a great deal of neon has been added, as the lower photo shows. Although the Cleveland's Casino sign may illustrate a bit of hopeful thinking, Northfield does offer more wagering opportunity than any facility of any kind in the state of Ohio.

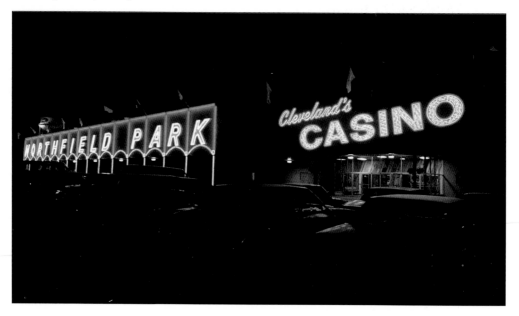

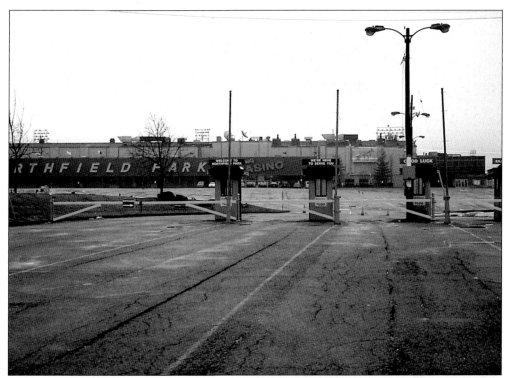

A shot of the exterior gates of the track just prior to the addition of office space and a huge neon message board. The office space houses Prestige Management, the Milstein family's real estate management firm and is directly below the animated horse on the wall.

For years, horsemen at Northfield lived in tack rooms, located in the barns on the backstretch. At Carl Milstein's insistence, a state-of-the-art groom's dormitory was built under Myron Charna's supervision, at a cost of $1 million. Charna recalls that the, "tack rooms were a shambles. The conditions were deplorable. The dorm, with subsidized rents, has been very successful and popular."

The track went to a Eurorail (pylon) configuration and added an inside passing lane in the summer of 1991. Horsemen were thrilled with the higher safety levels, while fans loved the additional racing opportunity that the passing lane provided. That's the Ford Plant water tower in the background.

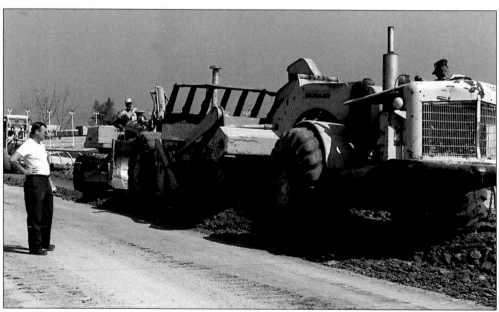

Here is a close-up of the construction equipment used for the Eurorail project.

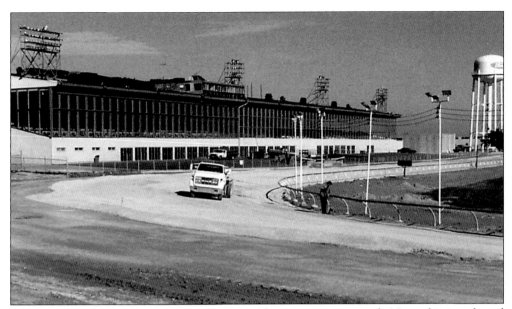

The grandstand as it appeared as the Eurorail project commenced. Note the grandstand windows, which have been slid into an open summertime position.

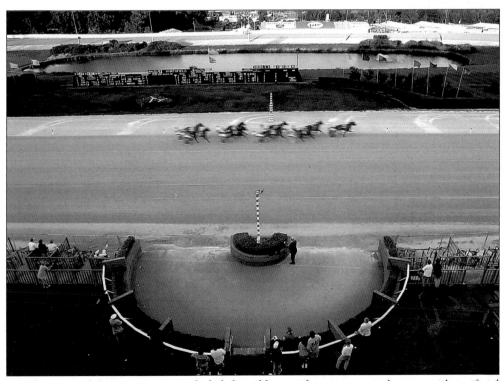

Another part of the renovation included the addition of a winners circle area, with artificial turf and lighting. Previously, winning horses returned to an area in front of the finish line on the track, where horses that were warming up had to avoid them. (Itamar Gat-Chagrin Valley Times Photo.)

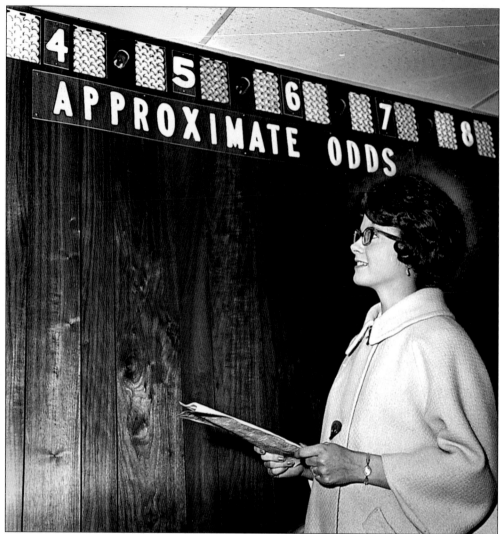

Gerry Bookmyer's wife Charlotte wants to make sure she gets a good price on her husband's horse. This odds board, in the corner of the clubhouse mezzanine, still exists as it did in this 1965 photo. Odds are determined by the amount bet on each horse. The track takes a standard percentage, about 20 percent, as a commission and has no interest in whether a favorite or a longshot wins.

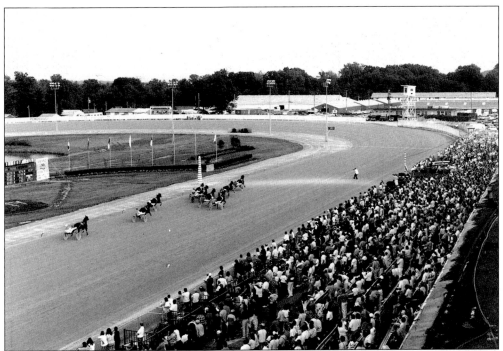

A huge summertime crowd watches the finish over the Flying Turns. Although Northfield's turns are not as highly banked as they used to be, the current banking helps make Northfield one of the fastest half-mile ovals in the sport.

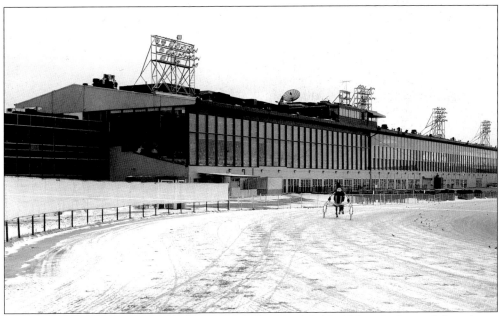

A horse warms up for a rare winter daytime card at Northfield. Although the track has always raced primarily at night, it experimented with winter matinees in the mid- and late 1990s when the local thoroughbred track was not racing. The orange cones cover the supports for the seasonal barbecue tent pavilion.

The track's clubhouse has always offered a great night out. This photo, taken just before a complete renovation and the introduction of a nightly buffet option shows the older small television monitors available at every table. They were replaced by 19-inch screens for simulcasting and sporting events.

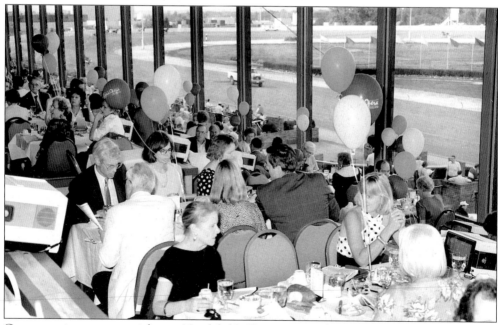

Group parties are a specialty at Northfield. You can see the great view of the track the clubhouse offers.

116

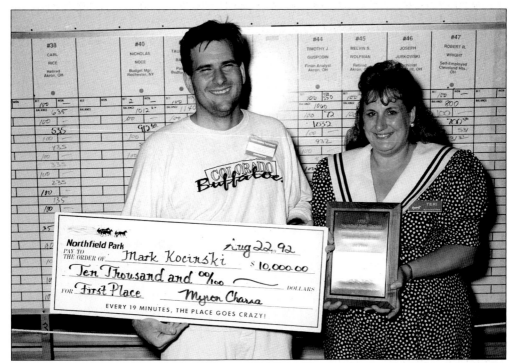

Handicapping contests have always been one of the most popular promotions at Northfield. Here is $10,000 winner Mark Kocinski in a 1992 tourney that featured Northfield's live card. Today, simulcast tracks are often involved in the contests.

The contests are updated regularly so that contestants always know where they stand. The track's most recent handicapping contests have served as qualifiers for the Coast Casinos $1 million Horseplayer World Series.

Contestants come from across the United States to compete. In the right foreground of the "World Series of Harness Handicapping" are Stephen Rowe of Florida, and Wayne Schneider of Pennsylvania.

Overflow crowds forced these tournament handicappers into the "cheap seats" in the upper grandstand. Today's contests are held in the television carrel area, with far more amenities.

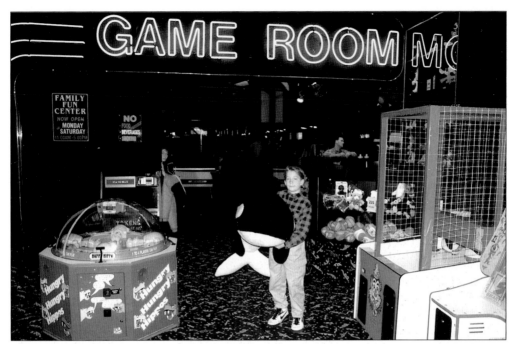

As the racing demographic ages, Northfield has tried to make itself appeal to families. A high-tech game room, where contestants can play air hockey, video games, and even skeeball gives parents a break during the evening.

The Kids Corner, with long time attendant Miss Barb, provides supervised care, coloring contests, and board games for youngsters.

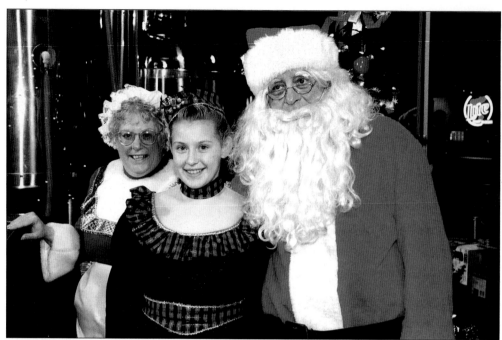

Holiday promotions, including the annual $25,000 Santa Sack Giveaway, are exceptionally popular. The Jolly Old Elf himself visits each year, accompanied by Mrs. Claus and a helper.

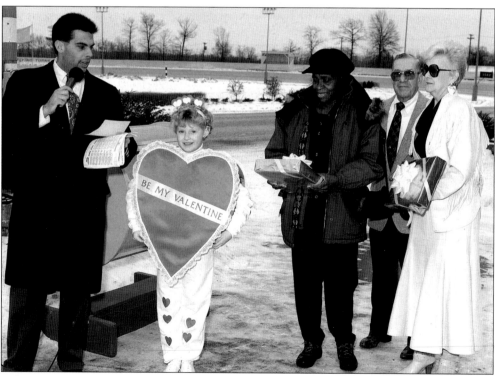

Valentine's promotions are also popular. Does Cupid look familiar? She is Laura Brininger, daughter of switchboard supervisor Sally Brininger.

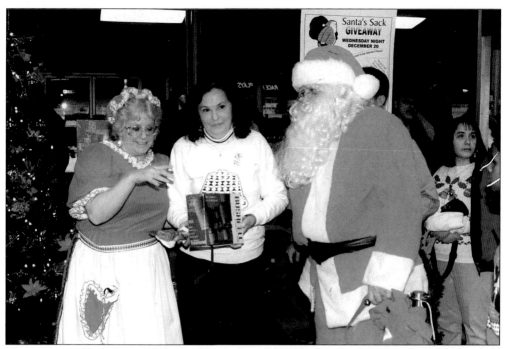

Santa presents Ruth Bernice of Akron with a pair of binoculars, the better to see her horse with as he flies down the backstretch.

The TV department is able to provide remote shoots from throughout the plant. Here they are preparing for the Santa Sack prize drawings in front of the microbrewery.

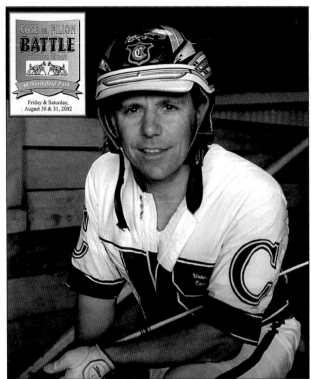

On Labor Day Weekend, 2002, Northfield offered the Battle of the Best, a unique driving competition between the two winningest drivers in American harness racing history—Herve Filion, who had over 14,500 wins at the time, and Walter Case Jr., with over 11,000. Any driver who won a race got a $200 bonus, the equivalent of winning an $8,000 race. Herve pulled ahead after the first day of the competition, but Case came on strong to win the contest on the second day. The event generated huge media attention, as did an autograph session featuring the two prior to the races.

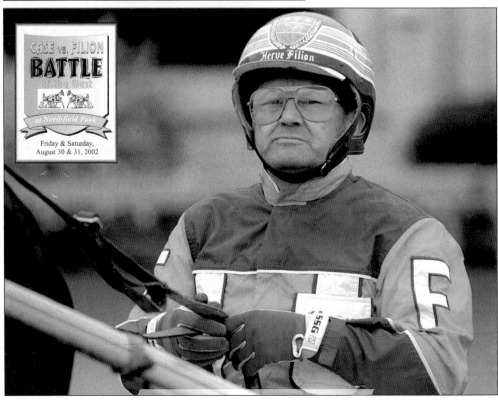

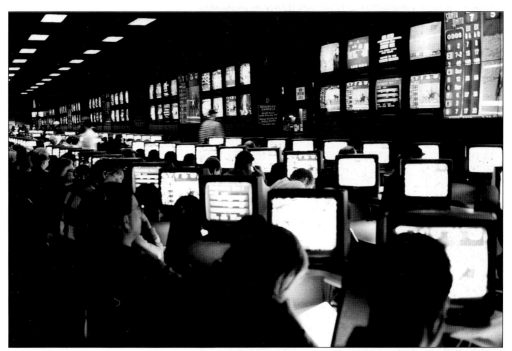

With the advent of full-card simulcasting in Ohio, in 1995, the track spent several million dollars in renovations. These state-of-the-art television carrels, or workstations, provide patrons with a lighted area to handicap, as well as access to the two dozen or more tracks available at any time.

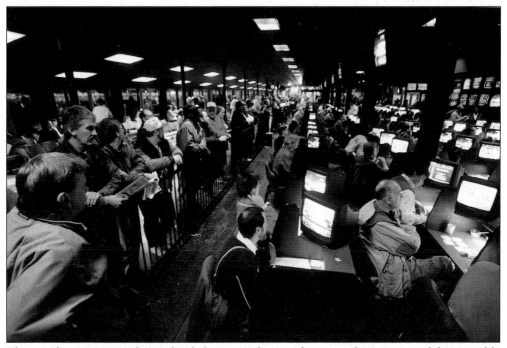

The simulcast area carrels are divided into smoking and non-smoking areas and feature table concession service.

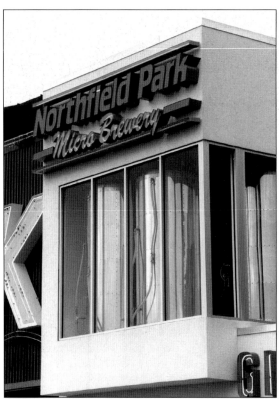

Northfield Park is the only racetrack in the world with its own microbrewery. Four standard selections—Winners Wheat, Silks Cream, Ale, Crimson Colt, and 40-1 Stout—are offered, with two seasonal brews available on a rotating basis.

The beer is brewed behind glass, where patrons can watch Master Brewer Dave Gunn at work.

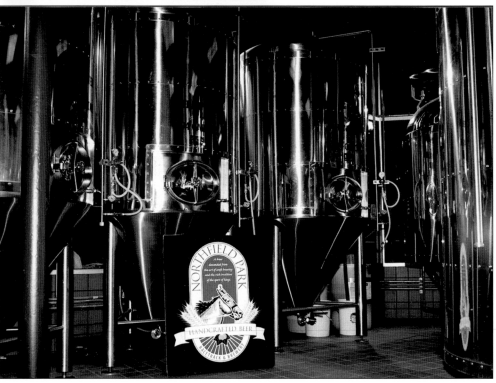

The toteboard at Northfield appears virtually unchanged since the 1950s, but the lights are now nearly all controlled by computer. It informs patrons of the odds, prices, and pools on the upcoming race.

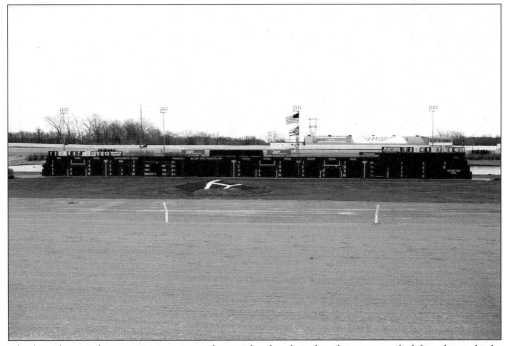

The board is nowhere near as exciting during the day, but this shot gives a feel for what it looks like when it's not lit up.

No wagering on the human 5K Please! Northfield hosts a unique run each year in conjunction with either the Battle of Lake Erie or Miller Lite Cleveland Classic. Several hundred competitors line up behind the mobile starting gate and race their first and last laps on the racetrack itself.

With the advent of full-card simulcasting, the old High Wheelers Lounge, which once featured announcer Bruce Michael Biro crooning after the races, was remodeled into the Winners Club, a private facility for big players.

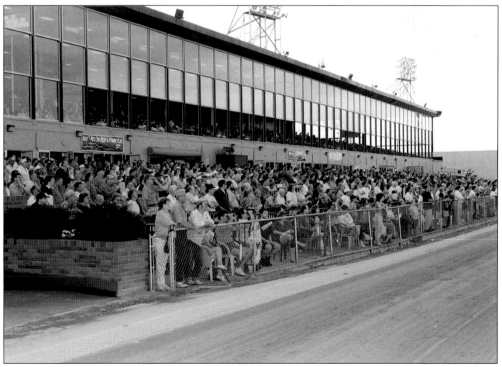

Regardless of the amenities indoors, many of Northfield's patrons still prefer the railbird experience, watching the races from outside.

Perhaps the trotter Galophone was psychic. Could he possibly have predicted the advent of telephone and Internet account wagering in this 1957 photo heralding the grand opening of Northfield Park?

WAGERING GUIDE

Regardless of what the future holds, Northfield remains well positioned to thrive. In 1992, it established the BetHarness.com and BetRunners.com account wagering system, in conjunction with AmericaTab. BetHarness.com is one of the fastest growing systems in the industry.